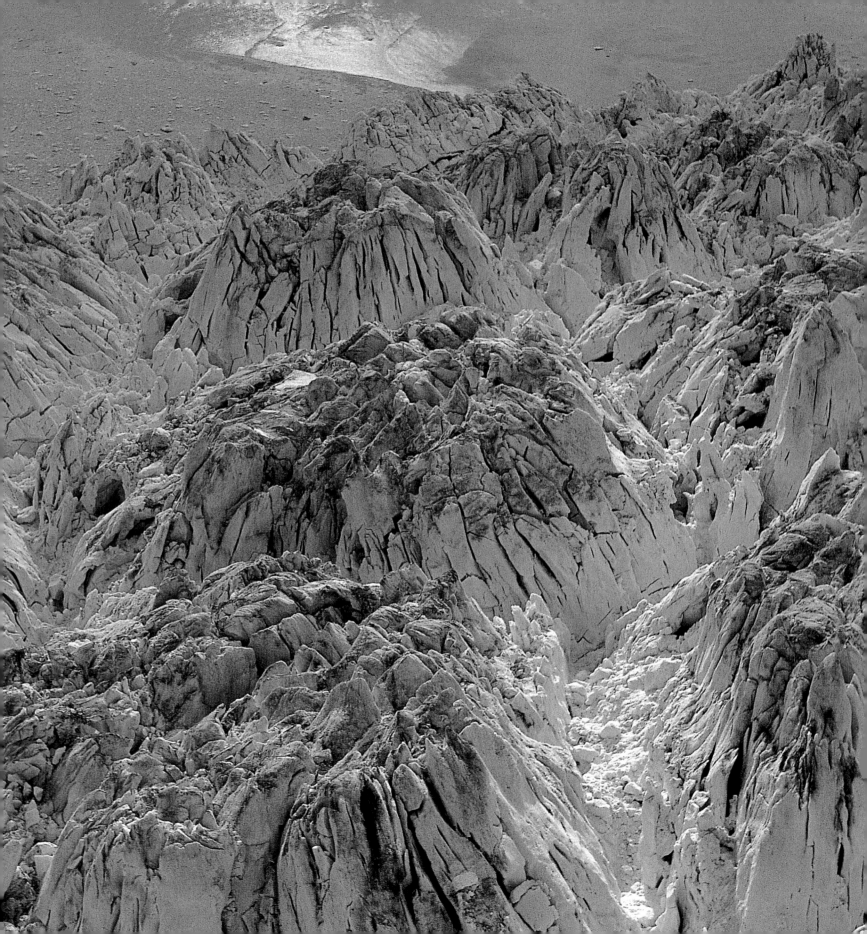

PICTURE JOURNEYS IN ALASKA'S

Wrangell-St. Elias

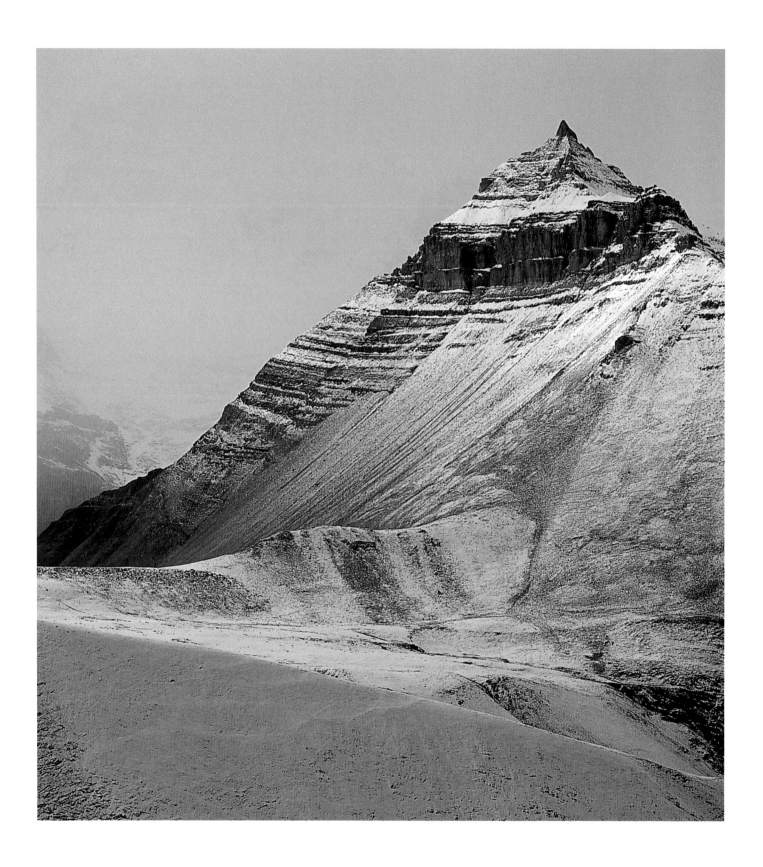

PICTURE JOURNEYS IN ALASKA'S

Wrangell-St. Elias

AMERICA'S LARGEST NATIONAL PARK

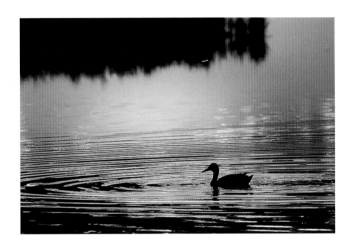

George Herben

Alaska Northwest Books™

Anchorage ♦ Seattle ♦ Portland

For my wife, Pat

Text and photographs copyright © 1997 by
George Herben
Foreword copyright © 1997 by George F. Mobley

Library of Congress Cataloging-in-Publication Data:
Herben, George, 1930–
 Picture journeys in Alaska's Wrangell–St. Elias:
America's largest national park / George Herben.
 p. cm.
 ISBN 0-88240-490-3 (softbound: alk. paper)
 ISBN 0-88240-496-2 (hardbound: alk. paper)
 1. Wrangell–St. Elias National Park and Preserve (Alaska)—
Pictorial works. I. Title.
F912.W74H47 1997
979.8'3—dc21 97–848
 CIP

Originating Editor: Marlene Blessing
Managing Editor: Ellen Harkins Wheat
Editor: Don Graydon
Designer: Constance Bollen
Map: Gray Mouse Graphics

Photographs. Front cover and pages 10–11: *Kennecott Erie Mine bunkhouse perches
a thousand feet above Root Glacier.* Back cover: *Trail to abandoned Nikolai Mine,
with St. Elias Range in the background (right); McCarthy resident John Adams returns
to town with his packhorses after a successful moose hunt (left top); A brown bear in
the Chugach Range (left bottom).* End papers: *Ice hummocks at the terminus of
Hubbard Glacier, called "haystacks" by geologists.* Page 4: *First snow on the divide
between Root Glacier and McCarthy Creek.* Page 5: *Duck at sunset on an unnamed
pond along the McCarthy road.* Pages 6–7: *Riders on the Nabesna road, north side of the
Wrangell Mountains.* Pages 8–9: *Mount Blackburn seen from Willow Lake on the
Richardson Highway.* Page 12: *Fairy slipper orchid* (Calypso bulbosa) *near McCarthy;
uncommon in Alaska.* Page 126: Author photograph courtesy of Marty Loken,
copyright © 1980.

Alaska Northwest Books™
An imprint of Graphic Arts Center Publishing Company
Editorial office: 2208 NW Market Street, Suite 300, Seattle, WA 98107
Catalog and order dept.: P.O. Box 10306, Portland, OR 97210
800-452-3032

Printed on acid-free recycled paper in Canada

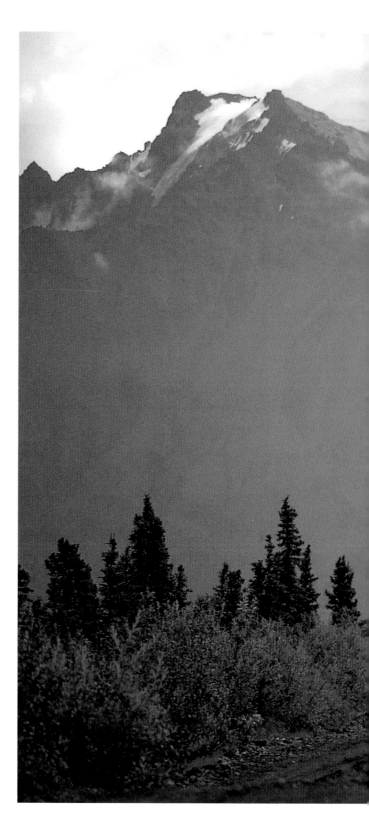

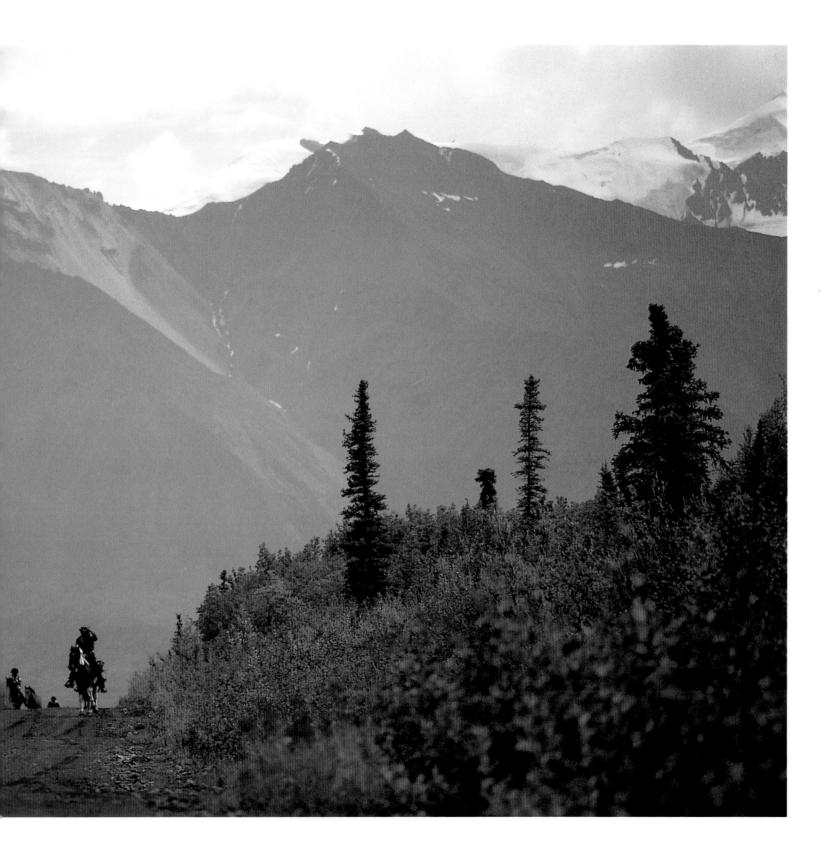

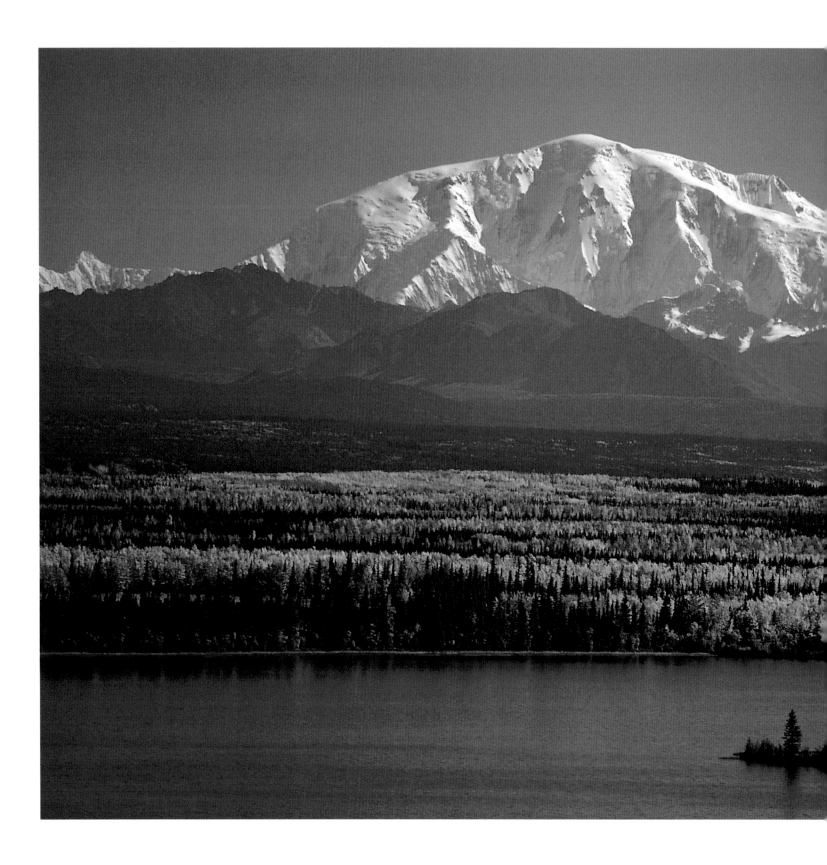

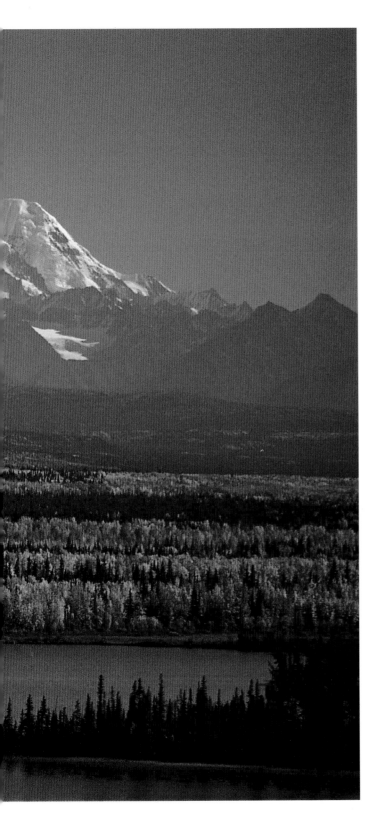

All America lies at the end of the wilderness road,

and our past is not a dead past but still lives in us.

Our forefathers had civilization inside themselves,

the wild outside. We live in the civilization they created,

but within us the wilderness still lingers.

What they dreamed, we live,

and what they lived, we dream.

———T. K. Whipple

Study Out the Land

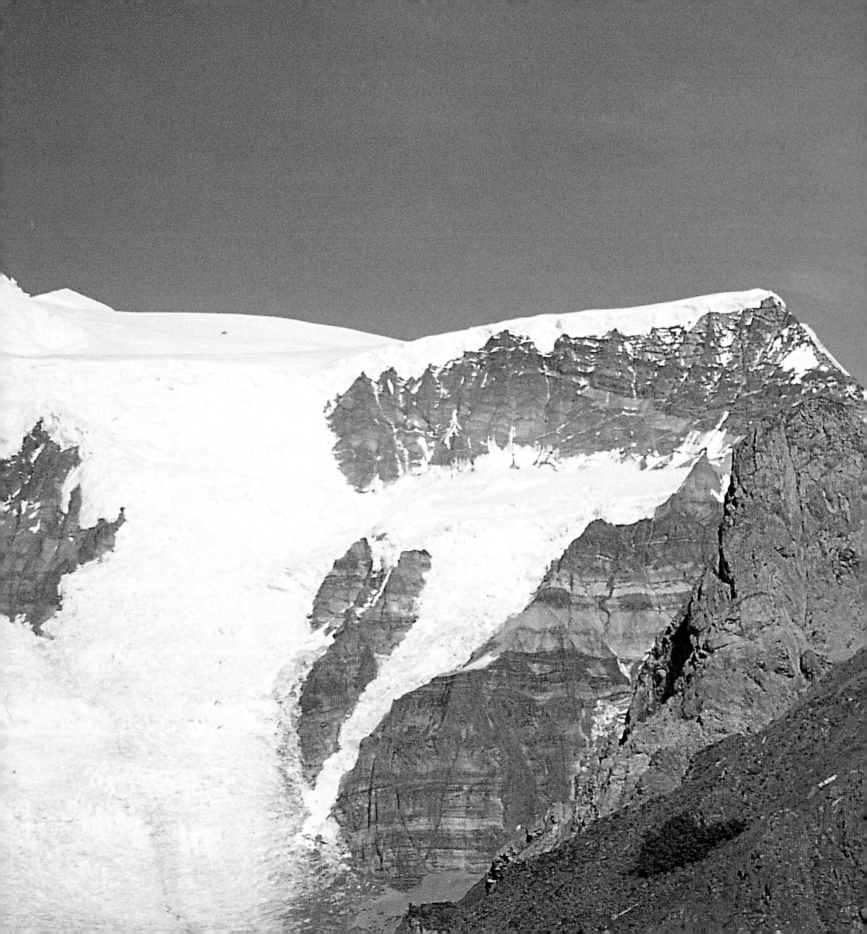

Contents

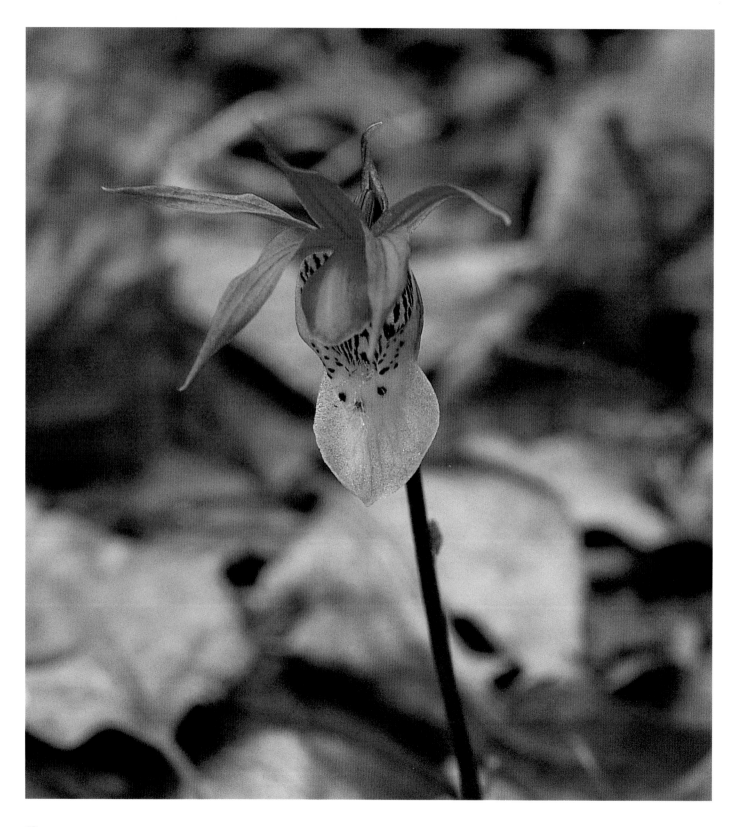

Foreword

Few things cast such an irresistible lure to some people while triggering anxiety in others as wilderness. I first glimpsed the vast wilderness of the Wrangell–St. Elias area in the spring of 1968 during the first of several Alaskan assignments as a staff photographer for *National Geographic* Magazine, and I was hooked. It was that same year that I met George Herben.

George became a long-time friend, and Wrangell–St. Elias a long-time mystery enticing me back again and again in an attempt to get to know this remote corner of Alaska. Sometimes George and I probed this mystery together, seeking to understand it and to record it on film or on the pages of memory.

Not an easy task. Wrangell–St. Elias National Park and Preserve comprises an area larger than New Hampshire and Vermont combined. More than 150 glaciers grind down from jagged mountains, four of which exceed 16,000 feet elevation. Only this century was Icy Bay released from the tenacious grip of the last ice age. Two crude gravel roads are all that enter the park; few trails penetrate the back country. Yet each year more visitors come to Wrangell–St. Elias.

The lyrical words and images in these pages reveal tumultuous vistas known only to the passing eyes of bush pilots. Through this book, we glimpse the priceless treasure safeguarded in this parkland and we better understand why it has been set aside along with adjacent areas in Alaska and Canada as a World Heritage Site. George's commitment to photographing this sublime landscape will help guarantee that it continues to be preserved for all of us.

Long before recorded history, the human experience was conceived in and born out of wilderness. In the deepest recesses of our hearts resonates a longing to reach out and once again grasp those primal roots. It is reassuring to know that the experience is available in those places of truly majestic wilderness—places like Wrangell–St. Elias.

—George F. Mobley
Mauertown, Virginia
March 7, 1997

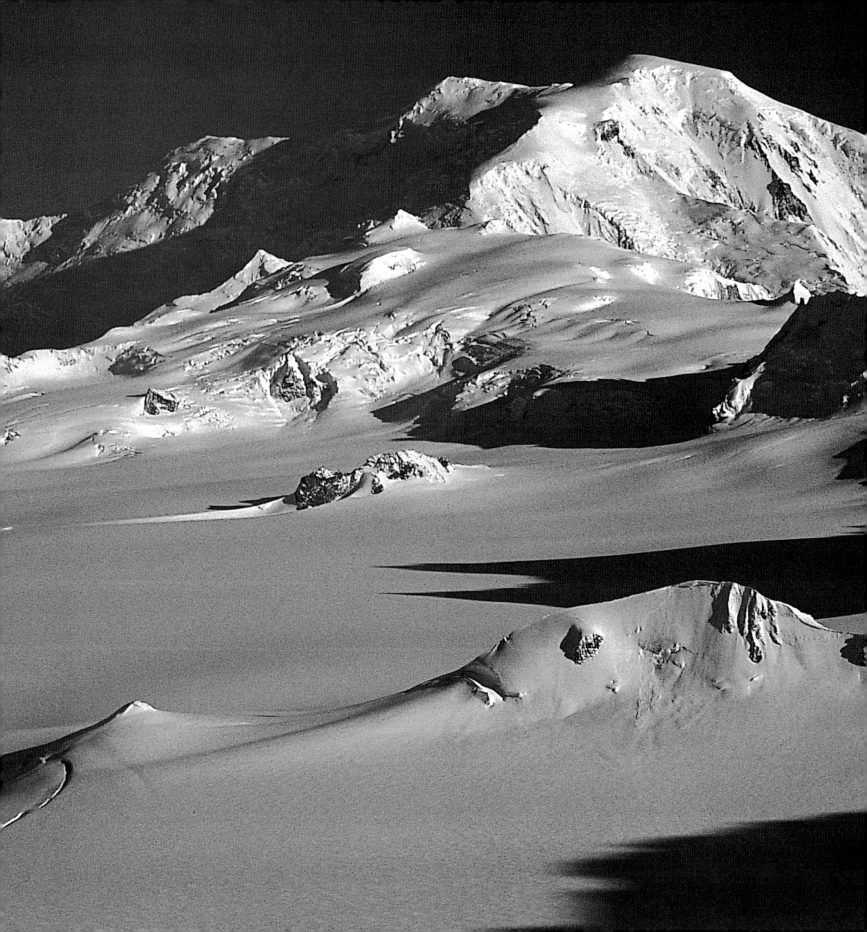

Discovering Wrangell–St. Elias

I saw Alaska's Wrangell–St. Elias region for the first time in 1954 when I journeyed by air into the heart of this spectacular mountain kingdom. That visit set the stage for a fascination that has yet to release its grip on my mind and heart. When I first stepped into the deserted mining town of Kennecott, I came into intimate touch with an era that had a sharp but fleeting impact on the region. As you raise your eyes above the decaying red-walled buildings of Kennecott and gaze into a seemingly endless realm of mountains and glaciers, you grasp a powerful truth: The mines had their day, but the mountains prevail.

Lakes, forests, alpine tundra, ice-clad peaks to 18,000 feet, and glaciers of all sizes and patterns dominate the specks of ghost towns and tiny human settlements. The scene is a visual feast. The geology and human history are enthralling.

Geologically, the changes wrought over eons are clear in the shapes, colors, and textures of the landforms. The four great mountain ranges that command this region—the Wrangell, St. Elias, Chugach, and Nutzotin—offer a thrilling glimpse of exceptional scenic variety. This area is a living geology text,

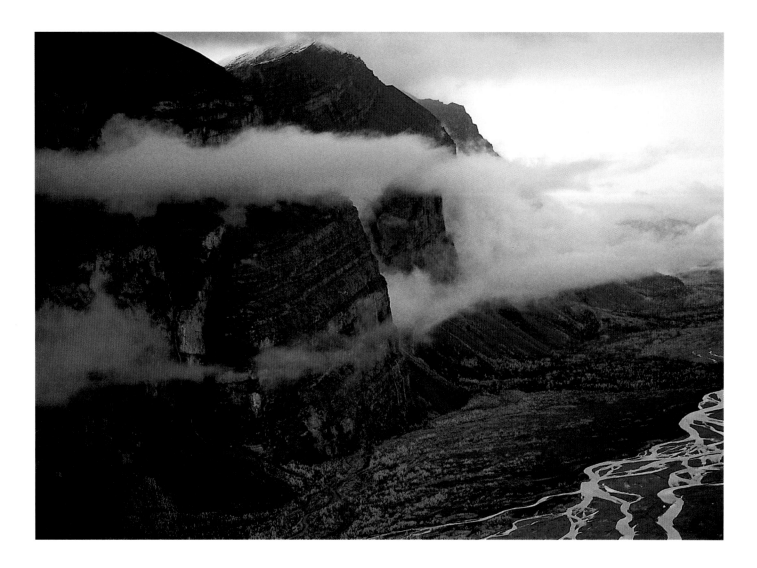

with limestone formations of grand dimensions and volcanic outpourings capping softer rock, all sculpted by ice and water and wind. Mud volcanoes dot the lower flanks of Mount Drum, volcanic steam is often visible at the summit of Mount Wrangell, and the folded and slanted bedding of thousands of feet of limestone is vividly apparent along the Nizina and Chitistone Rivers.

You don't have to be a geology student, though, to be struck by the drama and scale of this magnificent place. What you see here ranks high among this planet's splendid things.

Not very long ago, geologically speaking, no humans were here. The impact of the first Native people on this land was minimal—they hunted and gathered, made temporary encampments, and extracted copper from which they fashioned implements. Russian explorers of the eighteenth and nineteenth centuries traded here and used the area's resources on a limited scale,

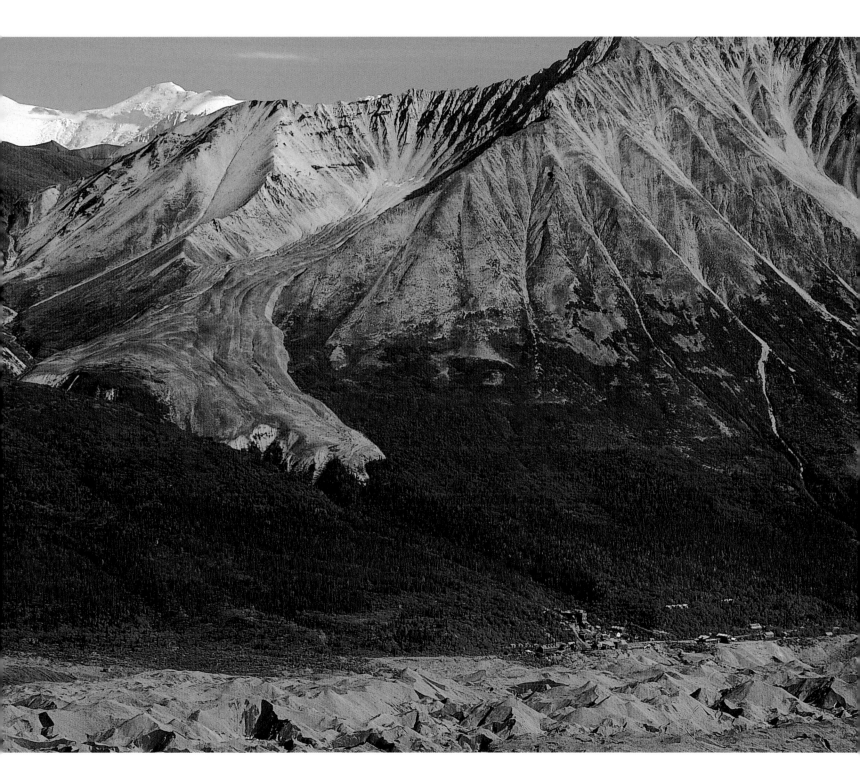

◀ The town of Kennecott is dwarfed by its mountain environment. A rock glacier dominates the hillside behind and to the left of Kennecott.

▶ Fireweed at sunset at Kennecott. Donohoe Peak and the Kennecott Mill are in the background.

▶▶ The Copper Glacier is the principal source of the headwaters of the Copper River. It heads in a valley between Mount Sanford and Mount Jarvis and, on the map, appears to follow a course shaped like a reversed question mark on its way to the sea east of Cordova.

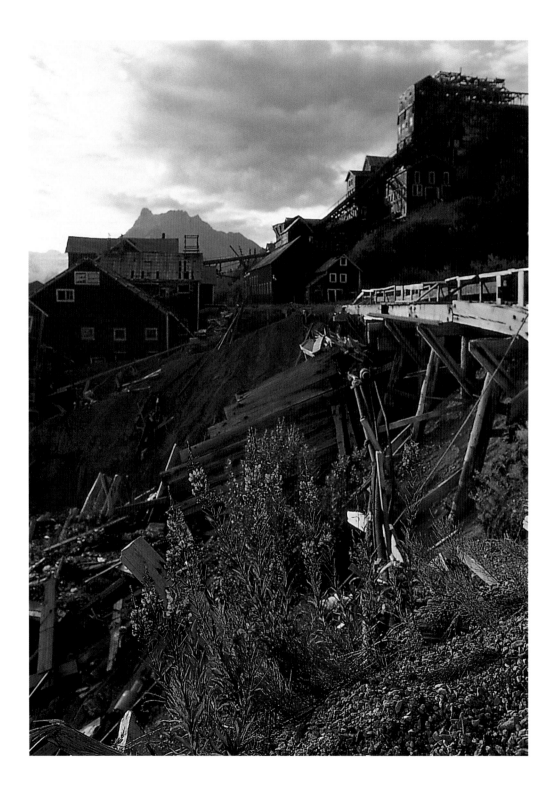

but withdrew after encountering considerable Native hostility. After the United States bought Alaska from Russia in 1867, the U.S. Army conducted a physical inventory of the new possession. Only then did the true dimensions and riches of this immense territory begin to emerge.

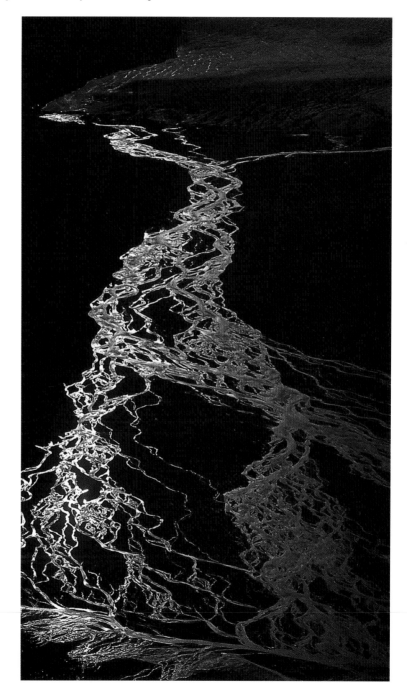

After the turn of the century, the process of getting to know Alaska accelerated greatly. As valuable mineral discoveries were made, interest in the geology and resources of the Wrangell–St. Elias region intensified. No change was so great as the one that began in the early 1900s with the discovery of startlingly rich copper ore deposits at the edge of the Chitina Valley on the southern slopes of the Wrangell Mountains some 240 air miles east of present-day Anchorage. A mining camp later known as Kennecott was constructed at the margin of a great valley glacier, 5 miles from its terminus, at an elevation of about 2,000 feet.

By the time the new Copper River and Northwestern Railroad reached Kennecott, 196 miles from its starting point at Cordova on the Gulf of Alaska, the mill was completed, mining had begun, and a permanent town was being built. The community of McCarthy developed just 5 miles downhill from Kennecott as a booming commercial adjunct to the company town.

For 27 years the Copper River and Northwestern linked the mineral resources of the Chitina Valley to the sea and the marketplace. From 1911 until 1938, more than 1.3 billion pounds of copper valued in excess of $200 million were extracted, processed, and shipped. But the depletion of commercial ore bodies brought radical change. In 1938, the mines were closed, railroad operations ceased, and the town of Kennecott was abandoned. With their principal livelihood gone and the

▶ **Johnson Hotel, McCarthy.** This old building has been restored and refurbished and is part of the McCarthy Lodge establishment.

▼ The old Copper River and Northwestern Railroad trestle 238 feet above the Kuskulana River is now used as a one-lane vehicular bridge on the road from Chitina to McCarthy.

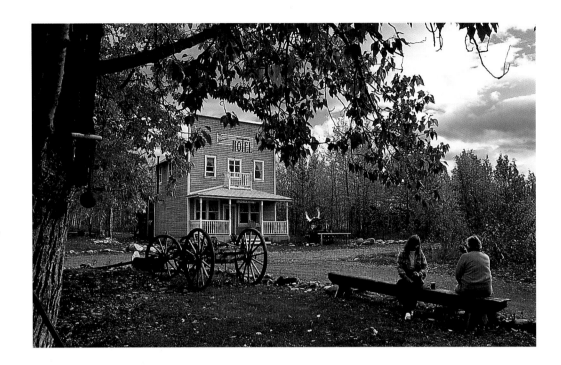

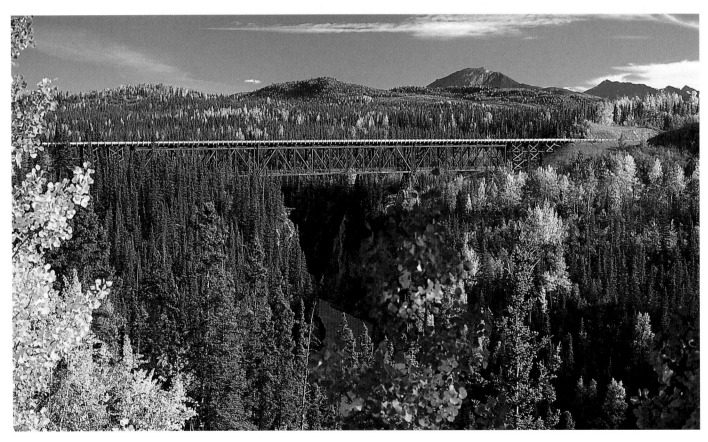

ground transportation link to the outside broken, the people who stayed in the valley found their way of life forever altered. Not until the early 1970s was the Copper River highway bridge built, giving cars and trucks access at Chitina to a rough 60-mile road to McCarthy on the old railroad bed.

In 1980, the vast and pristine land that spreads in all directions from the old mining area became Wrangell–St. Elias National Park and Preserve. At more than 13 million acres, it is the largest national park in the United States, the equal of six Yellowstones. At the same time the park was created, enclaves of nonparkland were specified. The road to McCarthy belongs to the state; McCarthy and the abandoned town of Kennecott are privately owned; some 600,000 acres surrounded by parklands are owned by a Native regional corporation.

▼ Capital Mountain is a remnant of a somewhat higher shield volcano active about 1 million years ago. The shoulder of Mount Sanford looms behind it.

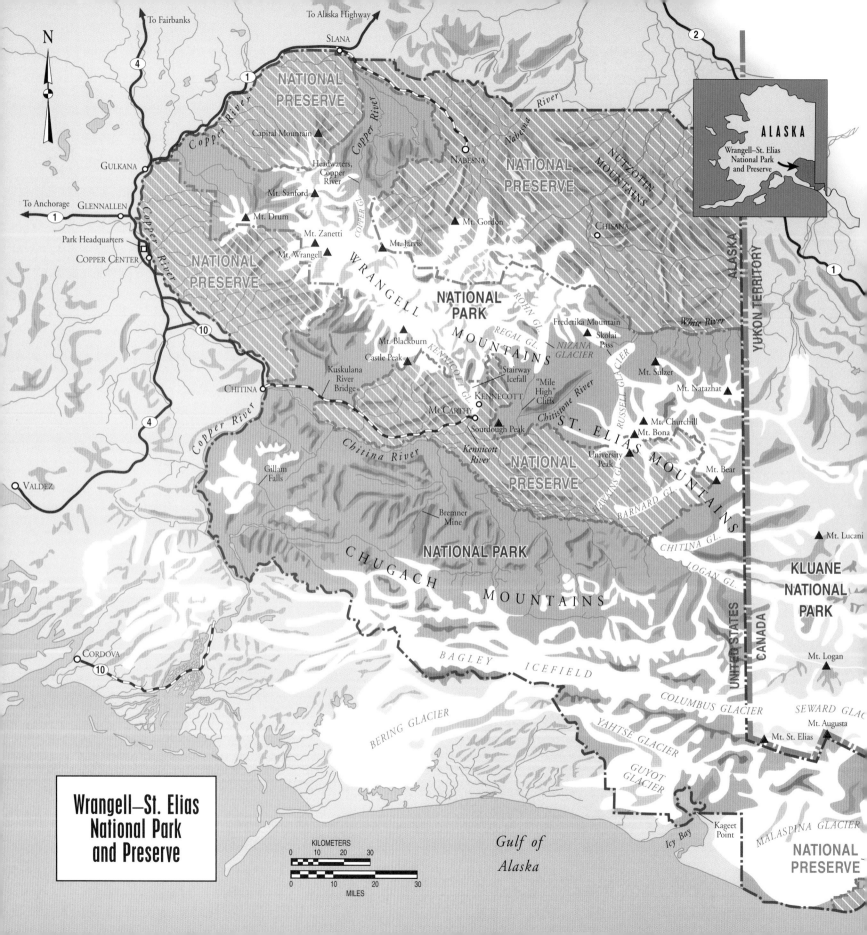

N

To Fairbanks
To Alaska Highway
SLANA

ALASKA

Wrangell–St. Elias
National Park
and Preserve

NATIONAL PRESERVE

GULKANA

Capital Mountain ▲

Headwaters, Copper River

NABESNA

NATIONAL PRESERVE

NUTZOTIN MOUNTAINS

To Anchorage
GLENNALLEN

Mt. Sanford ▲

Mt. Drum ▲

Mt. Zanetti ▲

Mt. Gordon ▲

Mt. Jarvis ▲

CHISANA

Park Headquarters

COPPER CENTER

NATIONAL PRESERVE

Mt. Wrangell ▲

Mt. Blackburn ▲

Castle Peak ▲

Kuskulana River Bridge

CHITINA

Copper River

WRANGELL MOUNTAINS

NATIONAL PARK

Rohn Gl.

Regal Gl.

Frederika Mountain ▲

NIZANA GLACIER

Skolai Pass

"Mile High" Cliffs

Mt. Sulzer ▲

Mt. Natazhat ▲

YUKON TERRITORY

Stairway Icefall

KENNECOTT

McCARTHY

Sourdough Peak ▲

Kennicott River

Chitistone River

Russell Glacier

ST. ELIAS MOUNTAINS

Mt. Churchill ▲
Mt. Bona ▲

University Peak ▲

Mt. Bear ▲

NATIONAL PRESERVE

Barnard Gl.

Chitina River

Gillam Falls

Bremner Mine

NATIONAL PARK

CHUGACH MOUNTAINS

Chitina Gl.

Logan Gl.

Mt. Lucani ▲

KLUANE NATIONAL PARK

VALDEZ

CORDOVA

BAGLEY ICEFIELD

BERING GLACIER

COLUMBUS GLACIER

YAHTSE GLACIER

Mt. Logan ▲

UNITED STATES CANADA

SEWARD GLAC

Mt. Augusta ▲

Mt. St. Elias ▲

GUYOT GLACIER

Icy Bay
Kageet Point

MALASPINA GLACIER

NATIONAL PRESERVE

Gulf of Alaska

KILOMETERS
0 10 20 30

0 10 20 30
MILES

Nine mountains in the park rise above 14,000 feet, with four of them reaching higher than 16,000 feet. Such mountain landscapes stand as the most beautiful in a state famed for the splendor of its peaks.

These grand surroundings have become for me a kind of spiritual refuge. I belong to this place and to its enduring beauty. Perhaps this book will help you understand why.

◆ ◆ ◆

I recall the day I walked up to the little cabin that my family keeps in McCarthy and found a bear's noseprint on the front window. A closer look revealed a couple of muddy paw prints on the sill.

So, Bear, what did you think? Did you like our little house?

I opened the door and stepped in, set my pack on the floor, and wondered what I'd have for lunch. Maybe the bear was wondering the same thing when his nose bumped against that transparent barrier. It must have seemed mysterious.

I've spent many years puzzling why these mountains have held such a deep fascination for me. In the years since my first visit, many spent across the world, my imagination kept carrying me back—a split second here, a long moment of contemplation there—until, sure enough, I'd always find a way to return and resume my search in this lovely place. I'm still turning up new mysteries and finding new wonders. But I must stop and show you what I've discovered so far. You can put your noseprint on my window if you promise to look carefully and not break anything.

WRANGELL—ST. ELIAS MOUNTAIN ELEVATIONS

Mountain	Elevation	Mountain	Elevation	Mountain	Elevation
Mount Logan	19,850'	University Peak	14,470'	Mount Sulzer	10,926'
Mount St. Elias	18,008'	Mount Wrangell	14,163'	Frederika Mountain	10,366'
Mount Bona	16,421'	Mount Augusta	14,070'	Castle Peak	10,190'
Mount Blackburn	16,390'	Regal Peak	13,845'	Tanada Peak	9,358'
Mount Churchill	15,638'	Mount Natazhat	13,435'	Mount Gordon	9,040'
Mount Vancouver	15,700'	Mount Jarvis	13,421'	Capital Mountain	7,731'
Mount Bear	14,831'	Mount Zanetti	13,009'	McCarthy Airport	1,531'
		Mount Drum	12,010'		

ELIAS

couver

MOUNTAINS

HUBBARD GLACIER

Disenchantment Bay

Russell Fiord

Nabesut Bay

BRITISH COLUMBIA

ALASKA

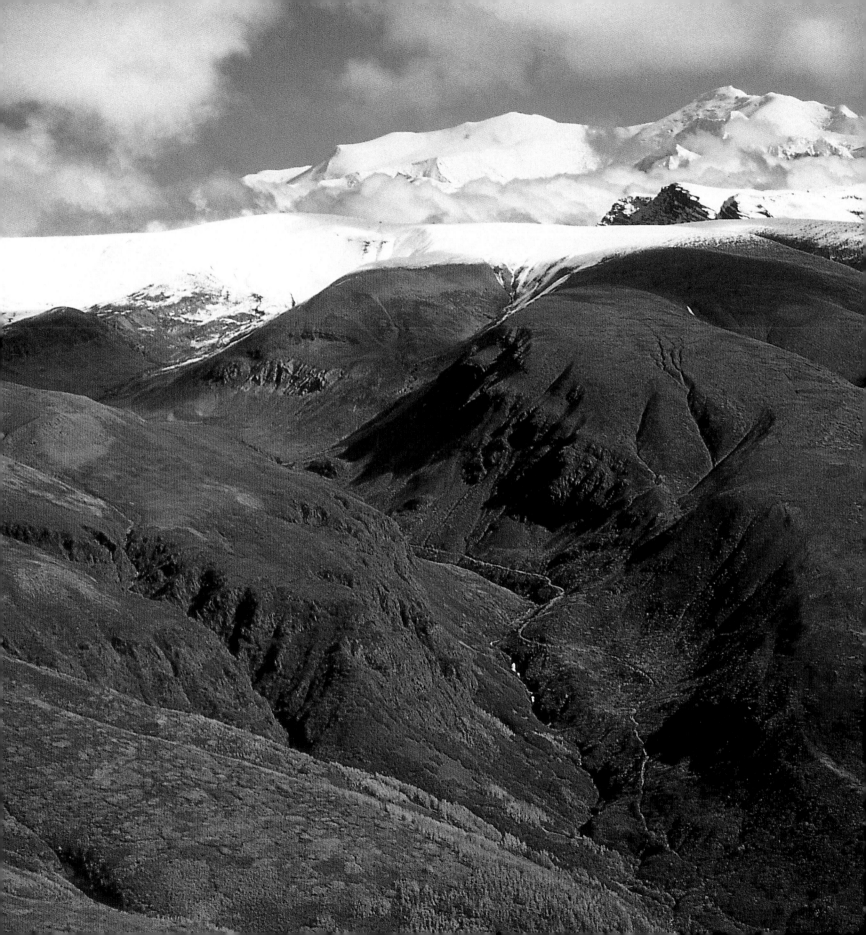

KENNECOTT COUNTRY
Mining the Past

Kennecott had been abandoned for only sixteen years when I made my earliest visit there, in the fall of 1954, and the town seemed no worse for that passage of time. I was a young man with a serious case of curiosity about this famous center of mining. My Kennecott visit began with a flight from Chitina to the McCarthy airstrip with a friend, a flight that took us over land that would later become part of Wrangell–St. Elias National Park and Preserve. It had rained just before we landed. The black cloud, still dumping rain, retreated into the mountains as we rattled in an old jeep from the airstrip into McCarthy.

After pausing briefly at McCarthy Lodge to down a cup of coffee and a piece of pie, we set off for Kennecott with packs on our backs and our heads full of anticipation. After all, Kennecott had been a complete small city long before we were born. What was it like now, we wondered; how would it feel to be alone in this ghost mining town? We talked less and less as we marched along the abandoned 5-mile wagon road from McCarthy to Kennecott. Rain had drenched the land. The sun appeared, slanting through a slot in the gray afternoon clouds,

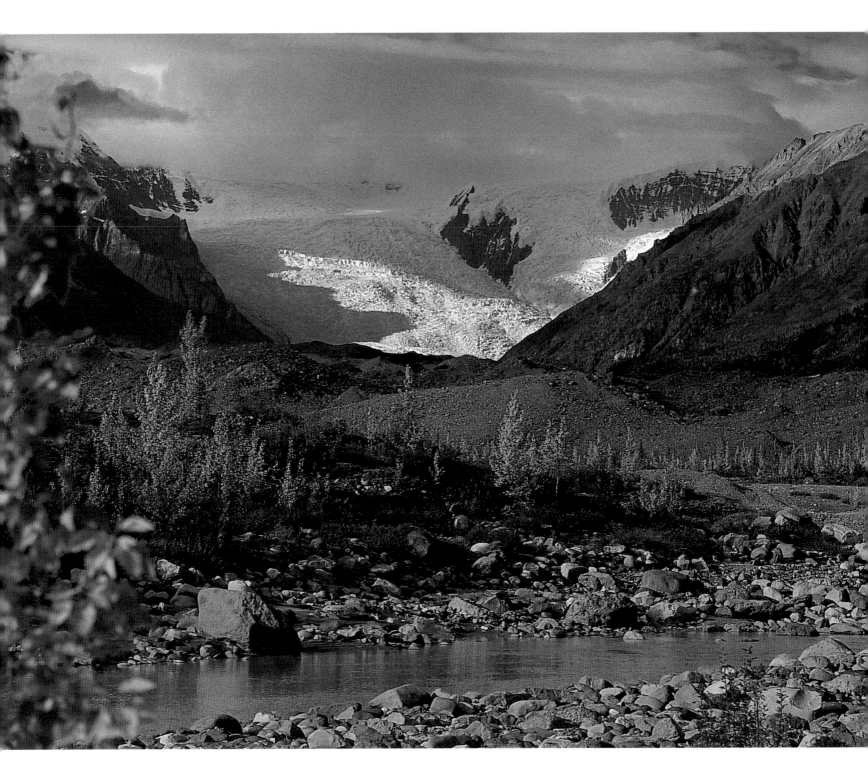

touching the changing willow and aspen leaves with orange and highlighting crystal sparkles on branches.

An hour passed and we came upon a little graveyard. As we contemplated the weathered wooden markers, we wondered about the families who had left someone here. Where were the families now? What did they remember of this place? On the road once more, we soon glimpsed the huge rock piles of moraine covering the surface of the glacier that touches the edge of the old mining town. Miniature mountain ranges, they draped the great glacier like an undulating blanket, making it seem more like an enormous mine dump than a river of ancient ice. A few minutes more, and we were there. A cool breeze rippled the branches nearby and a million raindrops pattered to the ground. Leaves blew along the road ahead of us and led the way into Kennecott.

What a place! A giant barn-red mill sprawled in tiers down the mountainside. Everywhere were red buildings trimmed in white so clean and fresh we couldn't believe no one lived here. Darkness found us in a furnished house. Curtains hung at the windows, and carpeting cushioned the floor. We discovered bedding, utensils, a woodstove, even kerosene lamps. The only things lacking were electric lights and running water. We had come prepared to camp, but all we needed was our food. When Kennecott closed, most furnishings, tools, and machinery were left because it was cheaper to abandon them than to ship them out of Alaska.

Some of the happiest experiences I can recall from our first foray into Kennecott came from trying to discover how it must have been to live there. I tried to see the town through the eyes of those whose home it had been and ended up seeing it through my own.

The history of Kennecott begins in the summer of 1900. One story has it that prospectors Jack Smith and Clarence Warner joined a group heading for Nikolai Creek to develop mining claims. Smith and Warner were searching for a western approach to the prominent rock "contact zone" clearly visible northeast of Kennecott Glacier—a place

◄◄ **Trail to abandoned Nikolai Mine. St. Elias Range is in the background.**

◄ **Stairway Icefall and Kennicott Glacier moraine on the east branch of the Kennicott River in the fall.**

▼ **A lone customer at an early breakfast in McCarthy Lodge.**

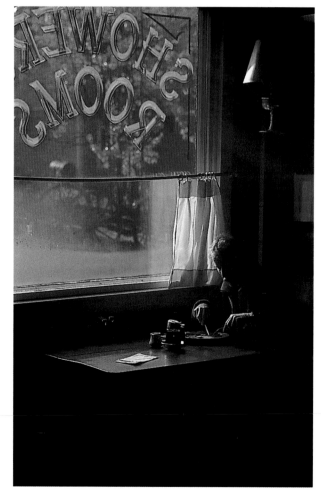

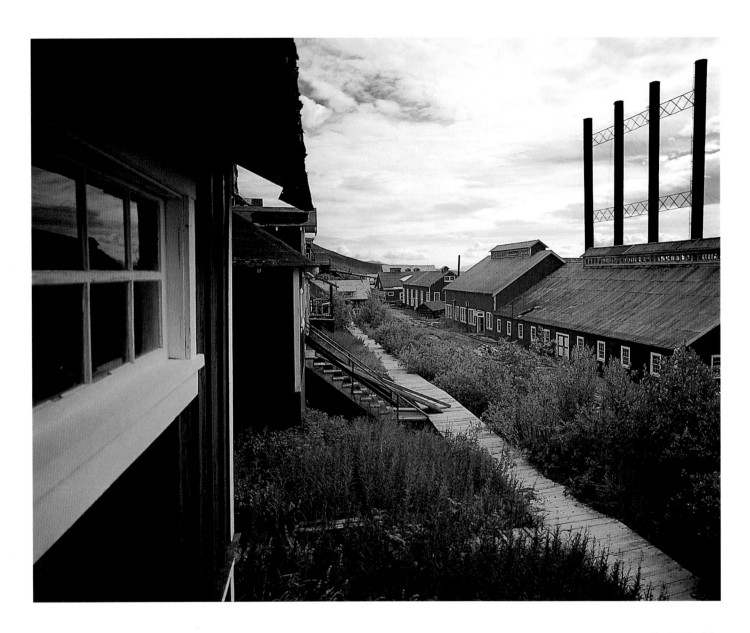

▲ The four huge exhaust stacks on the powerhouse at Kennecott could be seen from any location in the town. Homes, bunkhouses, hospital, and industrial buildings were heated by steam piped from the powerhouse.

where exposed light-hued limestone meets dark greenstone, a promising spot to find valuable minerals.

The two men progressed up the glacier to Bonanza Creek, where they turned upward past timberline. Continuing higher, they finally spotted the cliffs of green along the comb of the ridge that later came to be named Bonanza. Smith and Warner returned to Nikolai Creek to tell their friends. Later an eleven-partner association, Chitina Mining and Exploration Company, located

the Bonanza and several other claims along more than a mile of the limestone/greenstone contact. This outcrop proved to be one of the most dramatic surface showings of high-grade copper ore ever found.

That fall in Valdez, Alaska, a young New York mining engineer named Stephen Birch heard of the Bonanza find and bought a one-eleventh interest from a cash-strapped partner. H. O. Havemeyer, a wealthy friend of the Birch family who had financed Birch's explorations in Alaska, later backed the purchase of the remaining claims at prices up to $25,000 each. A new company, Alaska Copper and Coal Company, with Havemeyer as president and Birch as manager, succeeded in demonstrating very favorable possibilities for the claims. The copper had also lured bankers Daniel Guggenheim and J. P. Morgan. With their financial participation, the Alaska Syndicate was formed and ultimately owned or controlled the mines, the railroad, and the shipping line that took the copper to the smelter in Tacoma, Washington. In 1908 Kennecott Mines Company—a name taken from the Kennicott Glacier, but misspelled—became owner of the claims. The company was later incorporated as Kennecott Copper Corporation, with Stephen Birch as president.

▲ **Fall colors along the road between McCarthy and Kennecott.**

With the copper riches of the area proven, the challenge was to get the ore to market. The mine developers bought two railroad rights-of-way, both originating in settlements with port access to the Gulf of Alaska: Valdez and Katalla. Neither route proved practical. They finally struck a deal with railroad builder Michael J. Heney, who had started construction independently on a route beginning in Cordova. Heney was retained as construction manager.

The building of the Copper River and Northwestern Railroad was a major achievement. The line from the coast at Cordova crossed and recrossed the Copper River delta, passed close to the

▶ **Dwarf dogwood and a pebble of low-grade copper ore on Bonanza Ridge above the town of Kennecott.**

Childs Glacier via the Million Dollar Bridge, traversed the snout of Allen Glacier, passed through two canyons, and continued on to Chitina. There the railroad passed over the Copper River again and followed the Chitina Valley to mile 196 at Kennecott. Construction of the rail line, begun in 1907 and completed in 1911, cost more than $23 million. Today it would cost about $3 million per mile, or a total of some $600 million.

After the first shipment of ore from the Bonanza mine arrived in Cordova in April 1911, several other mines began development. The Jumbo mine, surpassing even the fabulous Bonanza in richness, opened in 1913. The Erie mine, high above the Root Glacier about 4 miles from Kennecott, started production three years later. The Mother Lode mine joined the group. Ore from all these mines moved by tram down the mountain to the giant mill in Kennecott. All the mines were connected by tunnels. The combined underground workings were more than 70 miles in length and are 2,800 feet below the tunnel portals at their greatest depth.

The sulfide ores were crushed in the mill and put up in large burlap sacks for rail shipment to Cordova, where they were loaded onto ships of the Alaska Steamship Company for the trip down the coast of Alaska and British Columbia to Washington state. In the smelter at Tacoma, these rich chunks of ore were turned into pure copper metal for eventual use in manufactured items such as electrical wire and cookware, and in creation of copper-base alloys like bronze and brass.

The town of Kennecott grew. The town's hospital was enlarged in 1916, and an employee dormitory was built. A white two-story cottage with bright, spacious rooms and a copper ore fireplace was erected for the mining company's general manager and his family. A recreation hall, grade school, and ball field perched on the edge of the glacier.

From school the children could look out into a strange world bounded by red-walled buildings and great mounds of glacial moraine. In the distance were a jumble of mountains, culminating in the shining bulk of Mount Blackburn, 3 miles high and 20 miles distant.

Down the road, the neighboring town of McCarthy also flourished, with restaurants, pool halls, brothels, a barber shop, and a general store. John Barrett originally staked out 296 acres for the townsite in 1906 and named it after a friend, James McCarthy, who had drowned in the Tonsina River. With its hotel, fraternal lodge, weekly newspaper, and range of other businesses, McCarthy offered goods and services often not available at Kennecott. Local boozemaking became popular during Prohibition in the 1920s and early '30s, and stories claim that train engineers would toot a special signal to warn moonshiners when a federal revenue agent was aboard, so that stills and other evidence could be hidden.

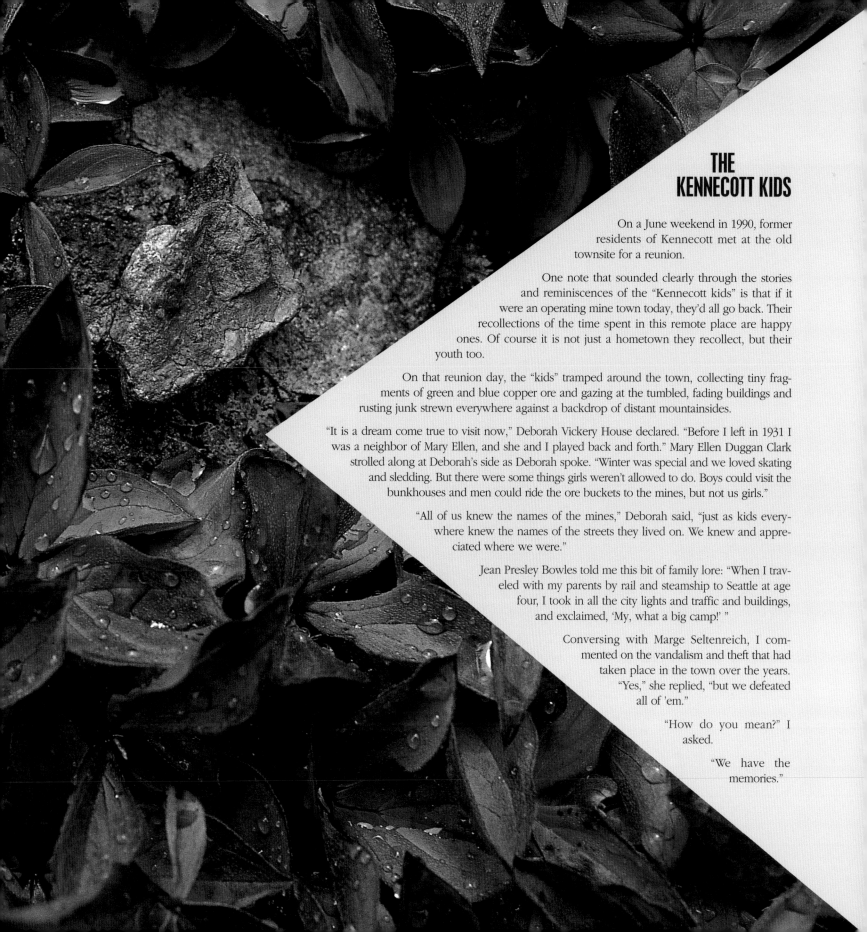

THE KENNECOTT KIDS

On a June weekend in 1990, former residents of Kennecott met at the old townsite for a reunion.

One note that sounded clearly through the stories and reminiscences of the "Kennecott kids" is that if it were an operating mine town today, they'd all go back. Their recollections of the time spent in this remote place are happy ones. Of course it is not just a hometown they recollect, but their youth too.

On that reunion day, the "kids" tramped around the town, collecting tiny fragments of green and blue copper ore and gazing at the tumbled, fading buildings and rusting junk strewn everywhere against a backdrop of distant mountainsides.

"It is a dream come true to visit now," Deborah Vickery House declared. "Before I left in 1931 I was a neighbor of Mary Ellen, and she and I played back and forth." Mary Ellen Duggan Clark strolled along at Deborah's side as Deborah spoke. "Winter was special and we loved skating and sledding. But there were some things girls weren't allowed to do. Boys could visit the bunkhouses and men could ride the ore buckets to the mines, but not us girls."

"All of us knew the names of the mines," Deborah said, "just as kids everywhere knew the names of the streets they lived on. We knew and appreciated where we were."

Jean Presley Bowles told me this bit of family lore: "When I traveled with my parents by rail and steamship to Seattle at age four, I took in all the city lights and traffic and buildings, and exclaimed, 'My, what a big camp!' "

Conversing with Marge Seltenreich, I commented on the vandalism and theft that had taken place in the town over the years. "Yes," she replied, "but we defeated all of 'em."

"How do you mean?" I asked.

"We have the memories."

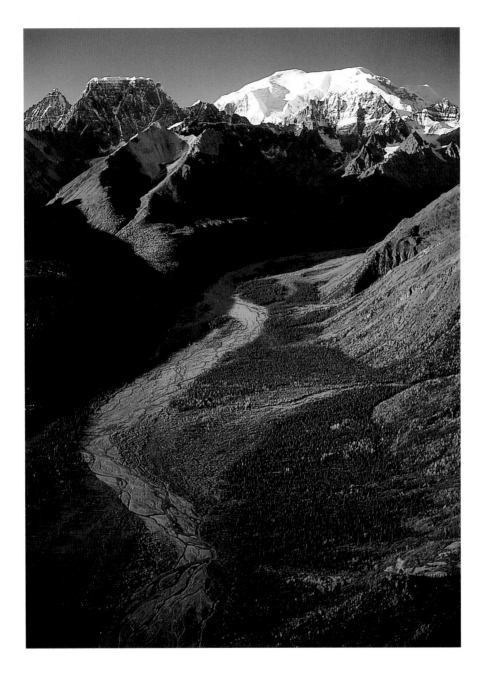

▲ **Fall color illuminates a valley near Castle Peak and Mount Blackburn. Lakina River is in the foreground.**

Kennecott's copper production rose to 120 million pounds by 1916 when nations were clamoring for copper during World War I. From 1915 until 1927, the total only once dipped below 50 million pounds per year. But after 1927, production declined and never again reached that figure. The Kennecott Company discontinued production in 1932 mainly because of the low price of copper. By 1935 when Kennecott reopened, it had become obvious that the mines would eventually run out of profitable ore and one day close permanently.

That day came in 1938, after a company report told of the exhaustion of all commercially valuable ore. The mines were closed, and the people of Kennecott departed. On November 14, 1938, train service was discontinued. With the coming of winter, the silence of wilderness gradually enfolded the town.

The passing of Kennecott and the railroad marked the end of a chapter in Alaskan history. Kennecott and McCarthy were population centers well before the first construction tents went up in 1915 on the site of what became Anchorage. Prospectors Smith and Warner had pinpointed the site for the fabulous Bonanza mine when even Fairbanks was still a blank on the map (a trading post wouldn't be established on the future site of Fairbanks until the following year, 1901). During World War I, Kennecott provided significant supplies of copper to a world in need of metals. Kennecott still retains its rank as the site of the purest deposits of copper ore ever found anywhere. But by the time World War II began, Kennecott had become part of the past.

The changes triggered by the closing of Kennecott and the cessation of rail service created small ghost towns along the broad Chitina River valley. The town of McCarthy dwindled to a handful of people, but for Kennecott, the silent, empty years began.

♦ ♦ ♦

On our first morning in Kennecott in 1954, sunlight was everywhere. I emerged from a warm bed and put my bare feet on the carpeted floor. There wasn't a sound as I sat on the edge of the bed, gathering my thoughts. At first I couldn't imagine where I was. Then the smell of bacon cooking got me moving.

We needed water for coffee so I rounded up a bucket and set off down the street in search of a stream. What better excuse to explore? I must have found water, but all I remember is Kennecott. I remember a strange feeling that came over me as I walked along. I felt watched. I felt there *must* be people here. The place was too well kept, too real, too alive to be a ghost town.

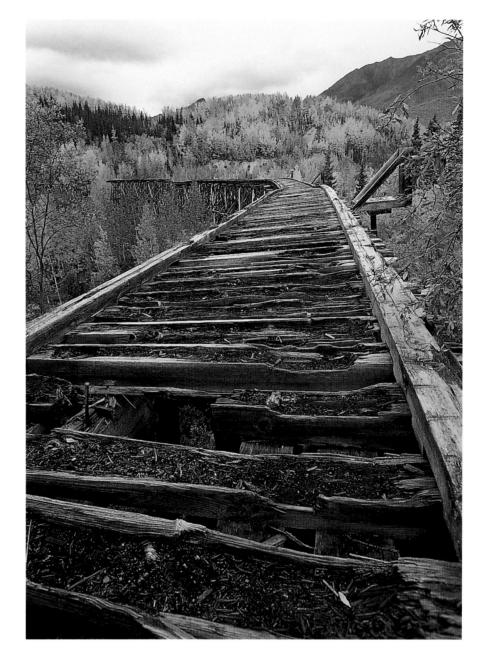

After breakfast we began exploring in earnest. We wormed our way through the giant mill from top to bottom. We gaped at the huge powerhouse with its four tall, black smokestacks. We investigated houses still furnished, and marveled at spare parts neatly organized in bins in a warehouse.

As we stood on the front porch of the manager's house, surveying the silent city at our feet, our imaginations for a moment brought Kennecott back to life. We could hear the rumble of the

▲ **Gilahina trestle on the abandoned Copper River and Northwestern Railroad about halfway between Chitina and McCarthy on the McCarthy Road.**

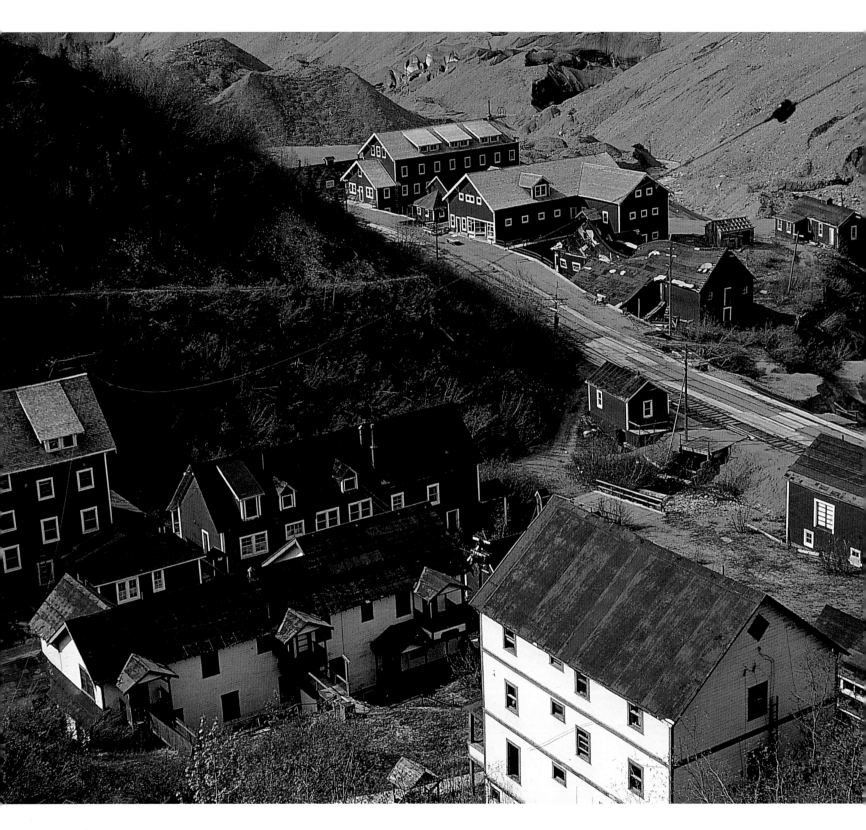

mill and see workmen passing between buildings, carrying tools. Tram buckets loaded with ore traveled on cables from the mines high above town to the platform at the top of the mill. Below on the tracks, dozens of flatcars were loaded and ready to move off down the grade to Cordova. A little store displayed ladies' hats and dresses in its plate-glass windows. Laundry fluttered in the sun on lines stretched behind houses on the green hillside, and wood smoke came from chimneys. Aromas from the kitchens drifted up to whet our appetites.

Finally after three days in Kennecott it was time to leave. We finished our remaining food, closed up the cozy little house, hoisted our packs, and started off down the road to McCarthy. As we rounded the first bend, I paused to look back while my friend went on. For a moment I was alone, the sole inhabitant of Kennecott.

Once more my imagination took over. I saw the train as people boarded for the last journey to Cordova over the rails Mike Heney laid so many years before. Kennecott was hushed now. The underground tunnels of the Erie, Jumbo, Bonanza, and Mother Lode mines no longer echoed the sound of miners at work. The tram cables hung motionless, suspended like steel spider strands over the flanks of the mountains above the mill. The mill and powerhouse were quiet. No voices cried out from the school. Homes and bunkhouses stood nestled against the green hillside as if waiting for their people to return. Shining peaks crowned by Mount Blackburn looked down upon it all as they had since the beginning, stern and mighty and beautiful, heedless of the frail human activity at their feet.

I stood in the road and shrugged my pack higher on my shoulders. Had I heard something? Was that the echo of a ghost train whistle rolling out through the hills?

◀ **The hospital, store, and bunkhouses in the abandoned mining town of Kennecott were still in near perfect condition in 1957. By 1996 many buildings were gone entirely.**

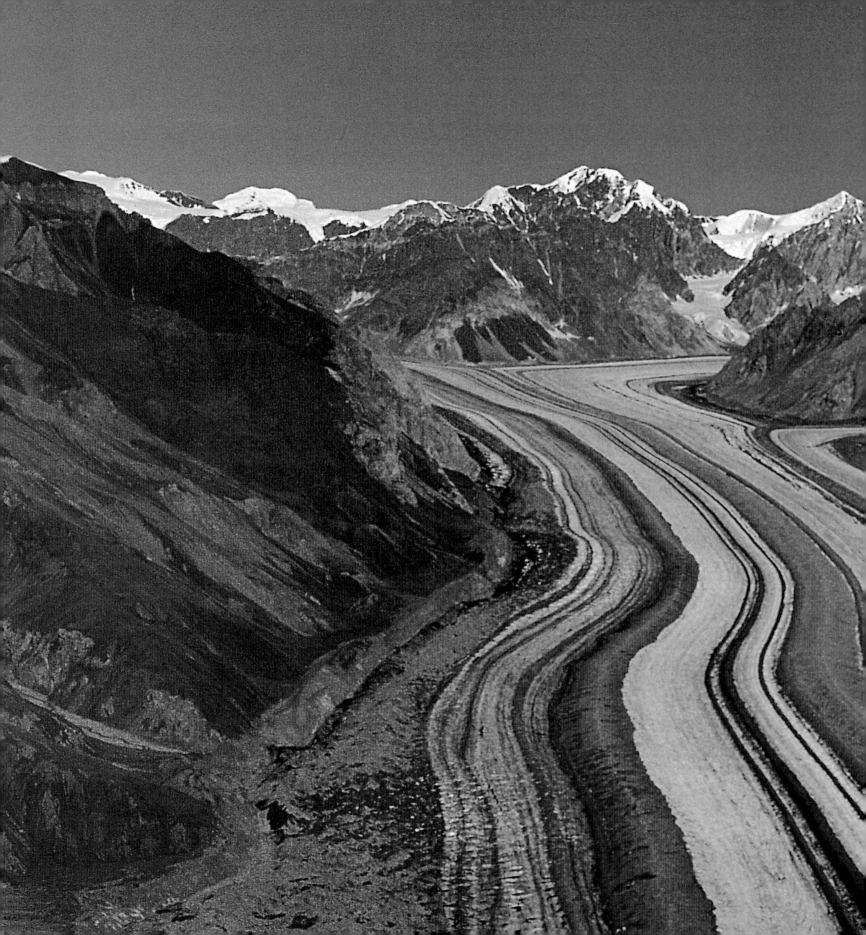

OUR LARGEST PARK
Nature's Drama

*T*he northeast sky brightened over Porphyry Ridge behind our cabin on the outskirts of McCarthy. Soon the little hill across the creek would be lit by the sun, bringing a clear spring day with the smells of green growing things and the sounds of birds.

Where will I go today, I wondered as I sniffed my morning coffee. I knew I'd fly somewhere with Gary Green and add to the store of pictures for this book, but where would we go? I hurriedly finished my coffee as I realized I'd better get moving if I wanted to make the most of the special morning light for pictures.

I took my empty cup inside, told my wife I was on my way, and pulled on my boots. I gathered a jacket, camera bag, some munchies, bug dope, and matches, put on my hat, and marched off to McCarthy, a few hundred yards away along the old Green Butte mine road. The sky was bright and the air cool, with trees forming a lacy green canopy overhead. The town was very still; McCarthy Lodge wouldn't open until eight, and no life stirred. The place seemed deserted.

◄ **Barnard Glacier in the eastern Wrangells has illustrated geology textbooks because it shows how medial moraine bands originate from moraines brought in from tributary glaciers.**

The sign in the window of the McCarthy Air office said OPEN, however, and I drank my third cup of coffee as Gary and I planned our route. He needed pictures of landing sites up the Chitina River to show to the hunters and hikers who hire him to fly them to remote locations. I agreed to shoot the pictures and make a sort of potluck morning of it. Soon we were off in Gary's all-terrain vehicle, churning along the dusty, potholed road to the airport.

The little red-and-white Piper Super Cub that crouched in its parking space in front of a patch of willows seemed to stare defiantly at us, as if declaring, "Go ahead, stuff yourselves and all that gear inside. I'll make you cramped and miserable within ten miles, you wait and see."

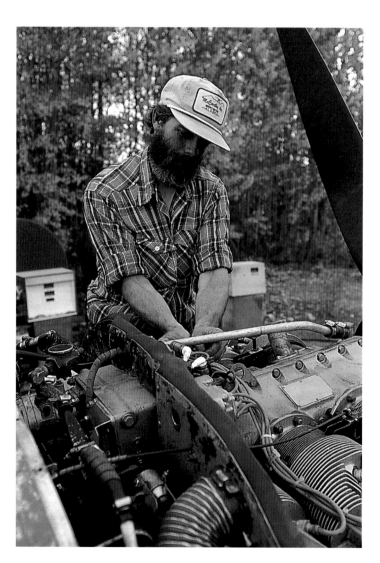

True enough. You don't ride in a Super Cub; you wear it. And if you have twenty-five pounds of photo gear to deal with, you end up wishing you were a midget—and that you hadn't loaded up on all that coffee. I finally squeezed my body and my camera bag into the passenger seat behind the pilot, while Gary reached in, primed the engine, and switched it on. He swung the prop and the engine coughed, smoked a little, and ran at idle. Gary climbed in and got settled, and we moved off. Soon the ground receded as we circled over the trees and headed east.

Ponds and small lakes passed beneath us. Most were shallow and swampy. You can't walk to within a hundred feet of most of these without sinking knee-deep in muskeg and icy water. But here was one pond coming up that looked different. There was solid ground right to the water's edge and an occasional clump of spring-green white birches to relieve the ever-present dark spruce. *Where would I build a cabin,* I asked myself, beginning to play one of my favorite "what if" games. I'd build right at the north end of the pond, I decided, on a point of high ground dotted with stands of birch and spruce and opening out to a pleasant view of mountains framing the Chitina Valley to the south.

As I'm flying, I often dream my way into pretty places as they pass below, imagining how it would be to live there. I've built little dream cabins all over the Wrangells. One

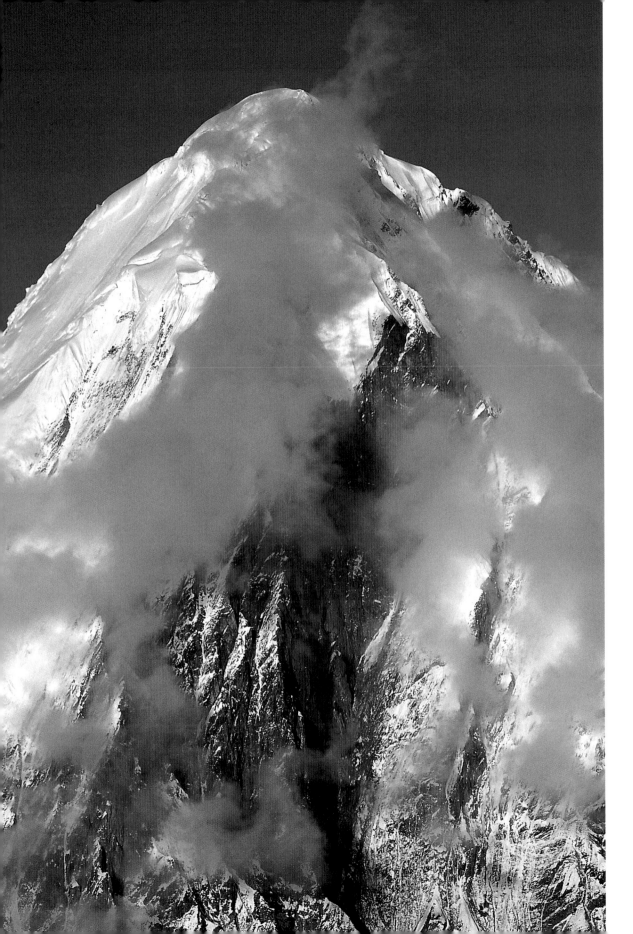

◀ ◀ Bush pilot Gary Green works on his Cessna 180 at the McCarthy airstrip. In the thousands of miles we've covered together, Gary frequently reads my mind and positions the airplane for pictures with only an occasional hand signal from me. A licensed aircraft mechanic, he performs most of his own maintenance.

◀ University Peak, a spectacular ice-clad mountain in the St. Elias Mountains between McCarthy and the Canada border. This mountain has not been climbed since the first ascent in the 1950s.

~ 39

▼ A young raven. These intelligent birds, related to crows, jays, and magpies, are common throughout Alaska. Getting close enough to one of them to obtain a frame-filling picture is a rare occurrence.

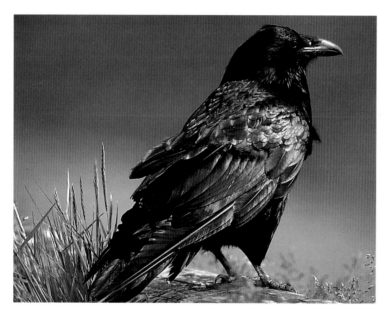

imagined cabin is situated on a sunny ridge bordering a swift glacial stream halfway up Barnard Glacier. On the day I spotted that special site, I was flying with the superintendent of Wrangell–St. Elias to check out a small portion of America's largest national park. We flew up the magnificent Barnard Glacier, its parallel medial moraines looking from the air like a multilane highway. My dream site had a spectacular view and was covered with mature trees that would be home to many birds and squirrels. A prime location, and a peaceful one considering there were no humans within fifty miles.

There was a problem, though. You couldn't get anywhere near the spot unless you were dropped off by air at the terminus of the glacier, hiked many rough miles up the glacier, and then turned up one of its tributaries. If you survived all that, there was still a near-vertical cliff to climb before getting to the home patch. But the nice thing about imaginary cabins like mine is that you don't have to struggle mightily over impossible terrain to get there. You just fly over, take a look, and then build it in your head.

Gary and I flew all the way up the Chitina Valley to scout several landing sites. The upper Chitina Valley is a hodgepodge of glacier moraines, pothole lakes, and braided streams. Many giant glaciers converge at the east end of the valley. On a clear day such as this one, you can see many miles into Canada's Yukon Territory, to the immense ice fields north of Mount Logan—at 19,850 feet, the second-highest peak in North America, only 470 feet lower than Alaska's Mount McKinley. Clearly visible on this day were the great masses of Logan and 17,147-foot Mount Lucania, both in Kluane National Park, Canada.

On a dark day, the upper Chitina can seem dismal and forbidding, a stark landscape that suggests the end of the world. In this sprawl of peaks east of Barnard Glacier and extending into Canada are scores of summits higher than 10,000 feet. Very few people other than dedicated mountaineers have ever seen any part of this remote land. It is a place of mystery, beyond the safe boundaries of the known. I've flown in many distant corners of our planet, and strange places are not especially strange to me, yet this area ranks with Tierra del Fuego and Canada's high arctic islands as both alluring and disquieting. The forces of erosion are unusually conspicuous here as

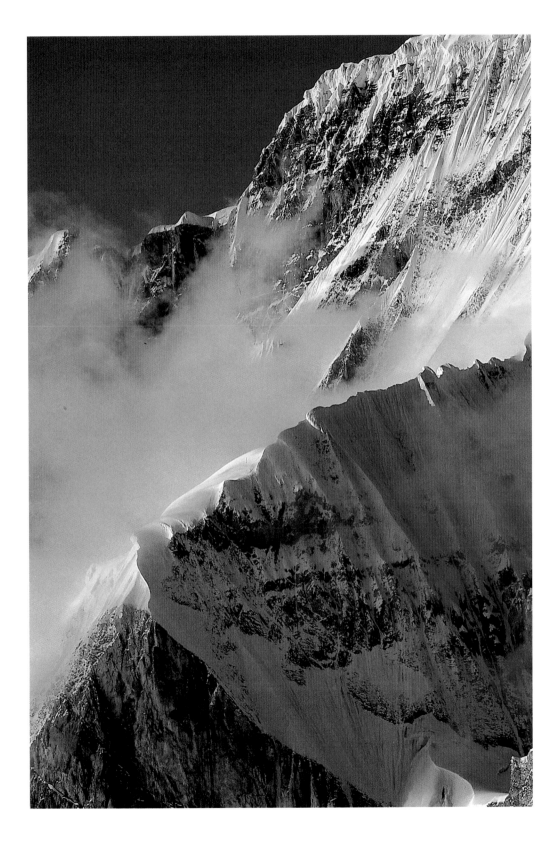

◄ Headwall of the cirque at Hawkins Glacier east of McCarthy.

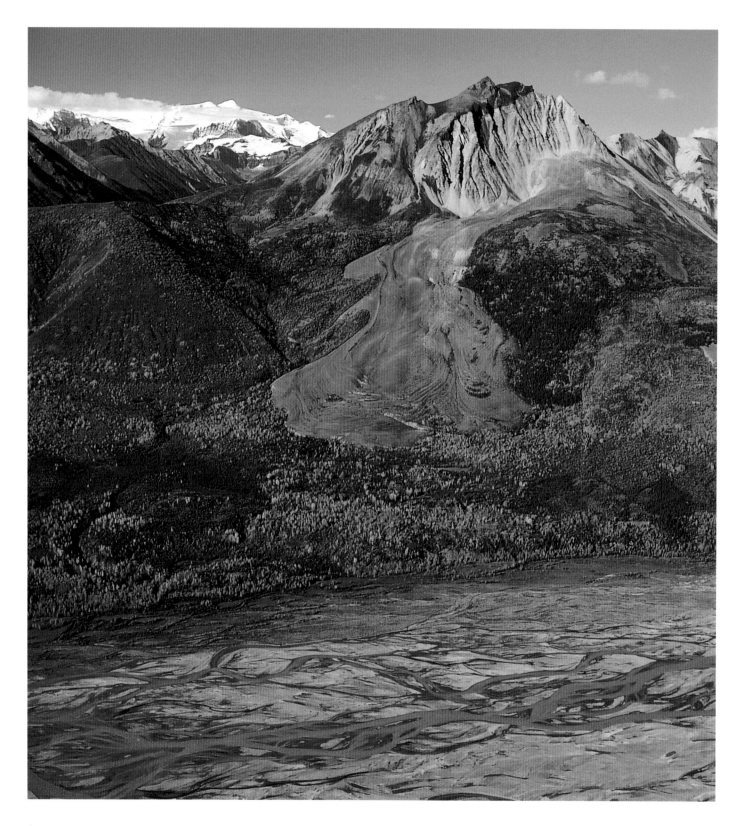

evidenced by the millions upon millions of tons of rock worn from high mountainsides by the forces of ice and carried by glaciers to fill the head of the valley and produce this moonscape. I have no dream cabins here.

After photographing a couple of potential landing spots, Gary and I swung west and flew along the northern side of the Chitina Valley, heading for McCarthy but meandering, probing the land beneath us, looking for anything interesting we hadn't seen before. We glanced up the Hawkins Glacier toward University Peak and the two pinnacles known as the Twaharpies (two harpies). At the head of the glacial valley, the cirque was now clear. The few clouds that had obscured this steep-walled, ice-filled basin on our eastbound leg had dissipated. Gary looked at me

and pointed up the glacier. I leaned forward and yelled, "Why not?" So instead of heading back to McCarthy, we turned and climbed upward toward the cirque 16 miles away.

The cirque, a boulder-strewn bowl of ice a couple of miles across, is a frigid fairyland so vastly different from the green, forested hillsides to the west as to seem to belong to another planet. We were flying at 8,000 feet, staying well above the glacier, which forms the bottom of the cirque at about 6,000 feet. Towering above us at elevations ranging from 11,000 to more than 14,000 feet were ridges and minarets of rock and snow. Fluted snow and ice covered many vertical surfaces. Spires of granite towered over us as we turned in slow circles through a dazzling world of white, blue, and gray. Most stupendous of all was University Peak, a 14,470-foot cone of 55-degree ice jammed against the sky, so close to us and so high above that Gary had to bank the plane sharply to give us a view of its top.

Cold air rushed in when I opened the window to shoot pictures. It seemed that every

◄ **Sourdough Peak rock glacier is a textbook example of this geological formation. Nizina River is in the foreground.**

▼ **Copper Lake is one of two large lakes near the northwest end of the park.**

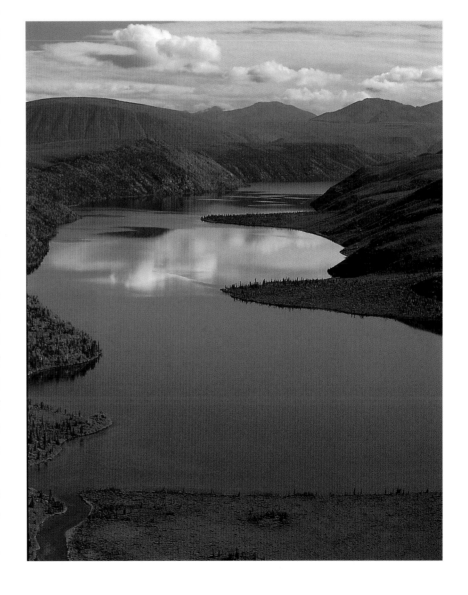

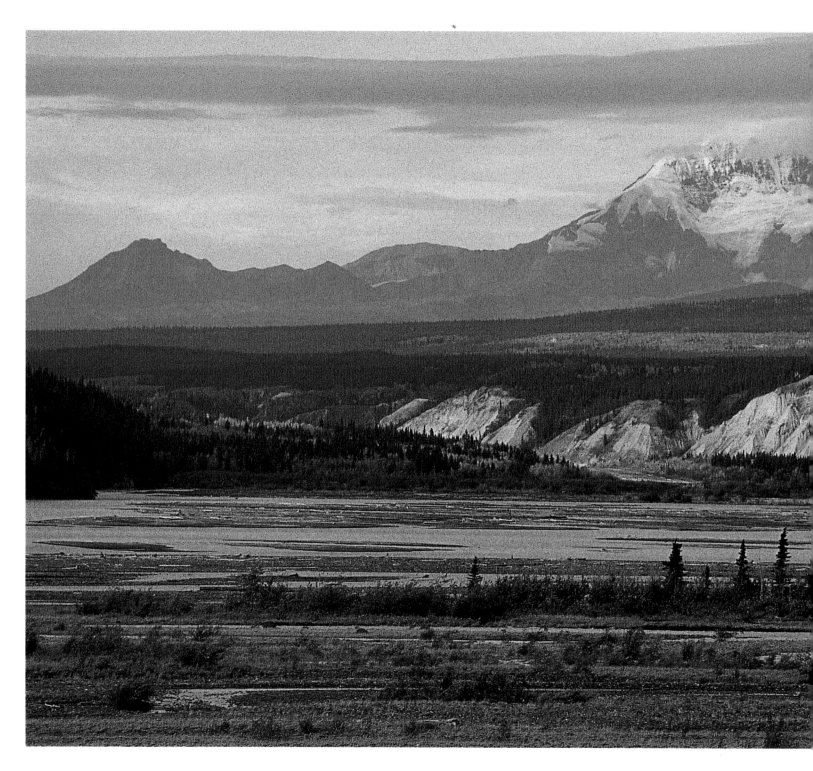

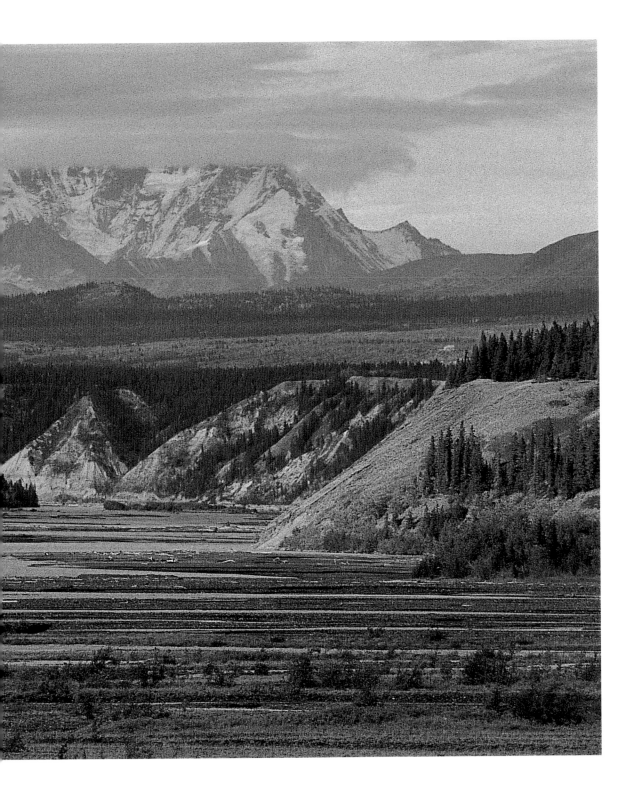

◄ Mount Drum seen from the confluence of the Kotsina and Copper Rivers.

▶ **Tide flows along the face of Hubbard Glacier into Russell Fiord from Disenchantment Bay.**

time I got some dramatic striated mountain wall in my sights, Gary had to turn away abruptly to avoid colliding with the scenery. It wasn't an easy place to work in. I didn't dare make suggestions about what I needed to get the best pictures because I had a strong impression that Gary shouldn't be distracted from the business of keeping us airborne.

A magic carpet was what I really needed to photograph this place: a platform in the sky, centered in the cirque high above the base of the towering cliffs. Then I could just point my camera at whatever struck my fancy without having the uneasy feeling that if Gary didn't exercise great care, we'd end up plastered against one of these lovely, deadly walls. We were so small! So infinitely small in this immensity of mountains and ice.

The time came when we had to find an exit and be satisfied with what we had seen and photographed. We ceased our circling, straightened our course down the valley, and when a notch appeared in the wall to the west, we sneaked through it. Imagine a tiny bug flying through the sharp, jagged teeth of an old-fashioned cross-cut saw; that's how it looked and felt, except that the teeth were 10,000 feet high.

Once through the notch we could descend. As we did, the air warmed, and a little green appeared to replace the gray and white and blue. The almost palpable hostility of the cirque was gradually replaced by forested ridges with rounder shapes, altogether a gentler view where excitement, awe, and a touch of fear were exchanged for a sigh of relief.

When we were back on the ground at McCarthy, we did what we always do after a safe return: we leaned on the airplane and talked about the flight. "You know what, George," Gary said, "that's the only place I've ever been where it feels like the mountains are going to fall on you."

◆　◆　◆

Long before the Wrangell–St. Elias region was established as a national park, Alaska Territorial Governor Ernest Gruening told the U.S. Department of the Interior that "the region is superlative in its scenic beauty and attractiveness and measures up fully and beyond the requirements for its establishment as a National Monument and later as a National Park.

"It is my personal view that from the standpoint of scenic beauty, it is the finest region in Alaska," Gruening said in his 1938 letter. "I will go further and state my belief that nowhere on the North American continent is such striking scenery to be seen."

The superintendent of Mount McKinley National Park (now Denali National Park and Preserve) enthusiastically agreed. After a tour, the superintendent wrote: "Among our national

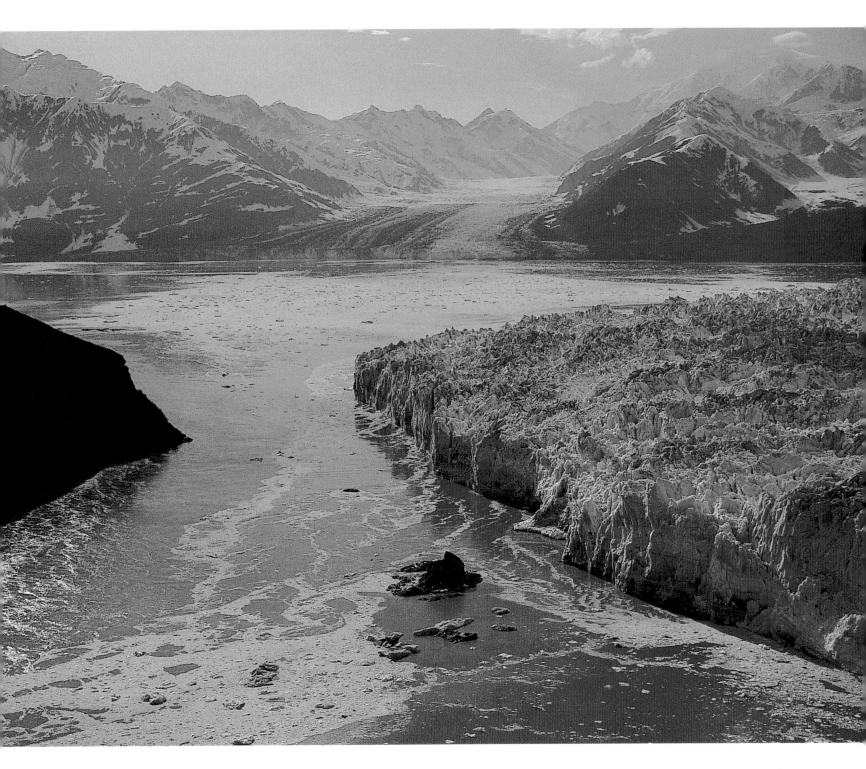

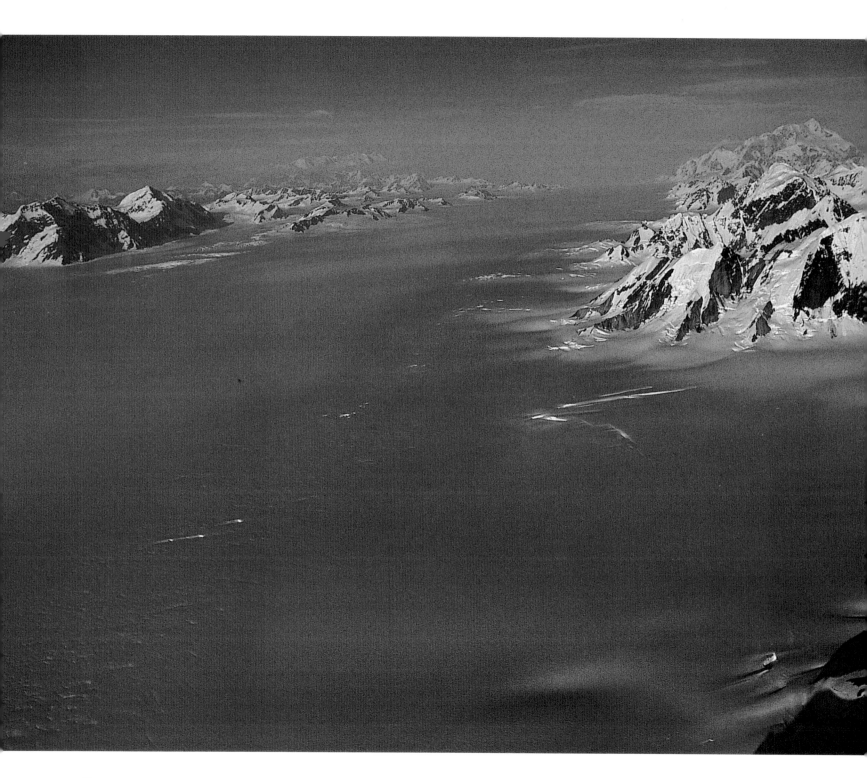

parks, it would rate with the best if in fact it would not even excel the mountain scenery of any of the existing national parks."

World War II put an end to park dreams. But statehood in 1959 helped bring about an all-encompassing look at land use in the new state, including the question of national parks. The Statehood Act authorized Alaska to select vast tracts for state ownership. The Alaska Native Claims Settlement Act of 1971, which granted 44 million acres to descendants of Alaska's original residents, also authorized the Interior Secretary to withdraw up to 80 million acres of "national interest lands" as possible national parks or other protected designations. With President Carter's signing of the Alaska National Interest Lands Conservation Act on December 2, 1980, the 13.2-million-acre Wrangell–St. Elias National Park and Preserve came into being.

This largest of all national parks in the United States is also a part of the largest protected land area on our planet, a 24-million-acre World Heritage Site designated by the United Nations. The site includes adjoining Kluane National Park in Canada, Tatshenshini–Alsek Provincial Park in Canada, and Glacier Bay National Park and Preserve in Alaska.

◆ ◆ ◆

By the time I've grown too old to climb into a small plane for a flight over my park, I will have gathered an endless storehouse of visual memories, both on film and in my mind. Photographs, powerful and telling as they may be, still fall short of the personal experience of seeing this magnificent land. On many flights I find myself viewing some particularly spectacular scene and saying, "Oh, wow, I have to look carefully so I can remember!"

There's an awful lot of "oh, wow!" in my 13-million-acre backyard. After more than forty years of seeing the place, I still get tears in my eyes as I gaze at an autumn-dappled river valley or forested lake. I'll turn to

◀ **The Bagley Icefield at dusk. In the distance on the left is Canada's Mount Logan, second highest peak in North America, and on the right is Mount St. Elias, highest mountain in the park and fourth highest in North America.**

▼ **Brown bear tracks in the sand at Kageet Point, Icy Bay.**

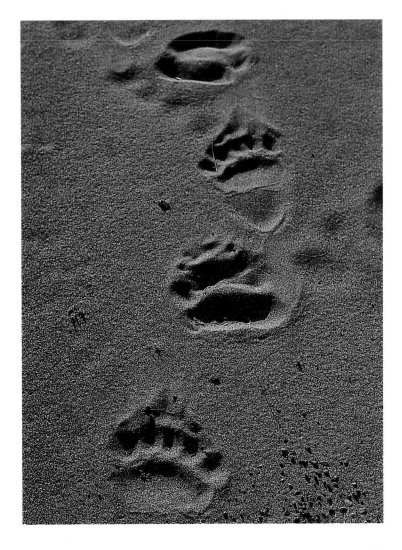

◄ A small pond on the McCarthy Road. Occasionally you see ducks, loons, or even swans on the ponds visible from the road.

▶ **A McCarthy Air sightseeing Piper Cherokee is dwarfed by mountains east of the upper Kennicott Glacier.**

▼ **A brown bear in the Chugach Range. The grizzly bear—the same species—is found in the Interior and is generally smaller.**

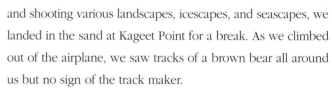

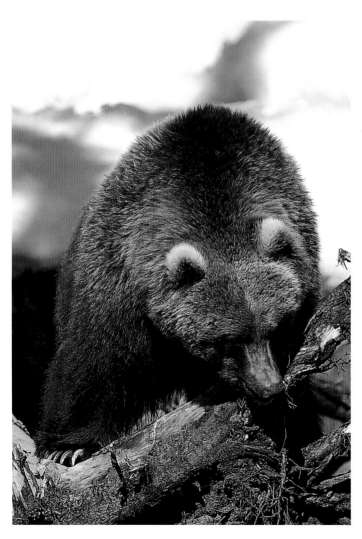

my friend, pilot Gary Green, and say something like, "Kinda pretty isn't it, that spot down there?" And Gary will say, "Sure is." And so we both pretend a little, concealing our emotions.

One sunny June day, Gary and I flew over the Chugach Mountains to Icy Bay, a straight-line flight of more than a hundred miles from McCarthy. It was midafternoon as we crossed the enormous Bagley Icefield, extending east and west beneath us as far as we could see. The largest subpolar ice field in North America, the Bagley is all of a piece with the immense Bering, Columbus, and Seward Glaciers. Major tributaries of the Bagley—the Yahtse, Guyot, Malaspina, and Hubbard Glaciers—flow to the sea. We headed down a smaller tributary, the Tyndall Glacier, to where it ends in an arm of Icy Bay and calves icebergs into the frigid waters. After examining and shooting various landscapes, icescapes, and seascapes, we landed in the sand at Kageet Point for a break. As we climbed out of the airplane, we saw tracks of a brown bear all around us but no sign of the track maker.

We walked along the beach in the golden sunlight, admiring shells and pebbles, snacking on pepperoni sticks and candy, and agreeing this was a prime picnic spot—provided we didn't have to share it with a bear. After a last sniff of salt air, we tucked ourselves into the plane and took off, heading east across a giant among glaciers, the Malaspina. Fed by relatively narrow ice tongues descending from ice fields above, the Malaspina spreads into a great bulb about 50 miles wide and 30 miles front to back, covering an area larger than the state of Rhode Island.

We flew off the east edge of the Malaspina and across the head of Disenchantment Bay, where the Hubbard Glacier was putting on a dramatic show. Everywhere we flew along the glacier's 7-mile-long front on the bay and neighboring Russell Fiord, we saw falling ice. Huge chunks and slabs crashed into the sea, at times audible over the noise of our plane.

Glaciologists say the continuing advance of Hubbard Glacier may soon—perhaps very early in the new century—cut Russell Fiord off from the sea. Then this 30-mile-long

FLIGHTSEEING

Bush flying in Alaska has always had an aura of romance, beginning with the pioneer pilots who often took risks that would cost them their licenses in today's world. Far safer now, flying in remote corners of Alaska is a pleasurable experience for visitors. Wrangell–St. Elias National Park and Preserve is so huge that flying is the most practical way to see the country. Air-taxi services in Gulkana, McCarthy, and along the Nabesna Road and other nearby locations can arrange backcountry drop-offs and pickups, affording hikers and climbers a chance to explore areas that might take days or weeks to reach on foot. Flightseeing routes are chosen to give a visitor the best opportunities to see landscapes, wildlife, or old mining areas, with durations to suit time and budget.

Local bush pilots also assist in search-and-rescue missions when rafters, climbers, or hikers run into trouble. It's reassuring to know that even though you may be far from "civilization," an air-taxi pilot can fly you to Glennallen or Anchorage quickly in a medical emergency.

Another comforting thought for people who may be a bit timid finding themselves in a tiny plane thousands of feet above exceedingly rugged mountains and glaciers: like his passengers, today's air-taxi pilot has a family he wants to return to at the end of the day, and if he gets home for dinner, so will you.

▶ **Ice from the face of advancing Hubbard Glacier crashes into Disenchantment Bay.**

fjord, one of the largest in western North America, will slowly turn from salt water to fresh, and many sea creatures will perish. As a freshwater lake, the former fjord may increase in depth and begin draining through a former outlet, the Situk River, to the sea. The geology of this region is not a static thing.

Across the face of the glacier we flew, photographing and marveling at nature's grand display of force. The drama was overwhelming. I became exhausted—not only from the effort to capture it all on film, but from sheer sensory overload. It was time to head for home.

Now we reversed course, back across the Malaspina Glacier while I made pictures of Mount St. Elias, rising to 18,008 feet only a few miles from the ocean. In July 1741, the mountain was Vitus Bering's first sight of mainland Alaska as this Danish explorer, in the service of Russia, traversed the Gulf of Alaska. On the border of Alaska and Canada, St. Elias is the highest peak in the park, and the fourth highest in North America. We turned inland at Yahtse Glacier and climbed toward the Bagley Icefield on our route home to McCarthy. Soon we droned along above an unbroken ocean of ice, pink and gray in the approaching twilight. Far to the east in Canada rose Mount Logan, standing even taller than St. Elias, which now framed the other side of the ice field.

I sat, tired and thoughtful, looking forward to quiet and a hot dinner in my little cabin in McCarthy, where all would be green and summery instead of white and blue and cold. I glanced at Gary, who sat with his hand on the yoke, gazing ahead along our flight path. He looked at me and I asked, "Hungry?" He replied, "Yeah," and added, "It's been quite a day."

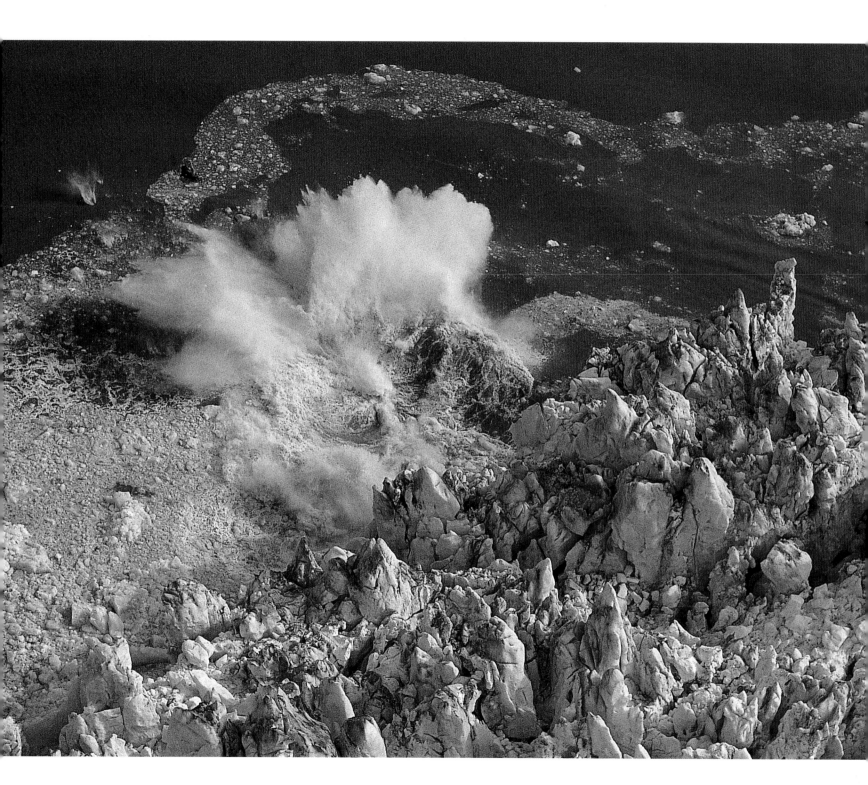

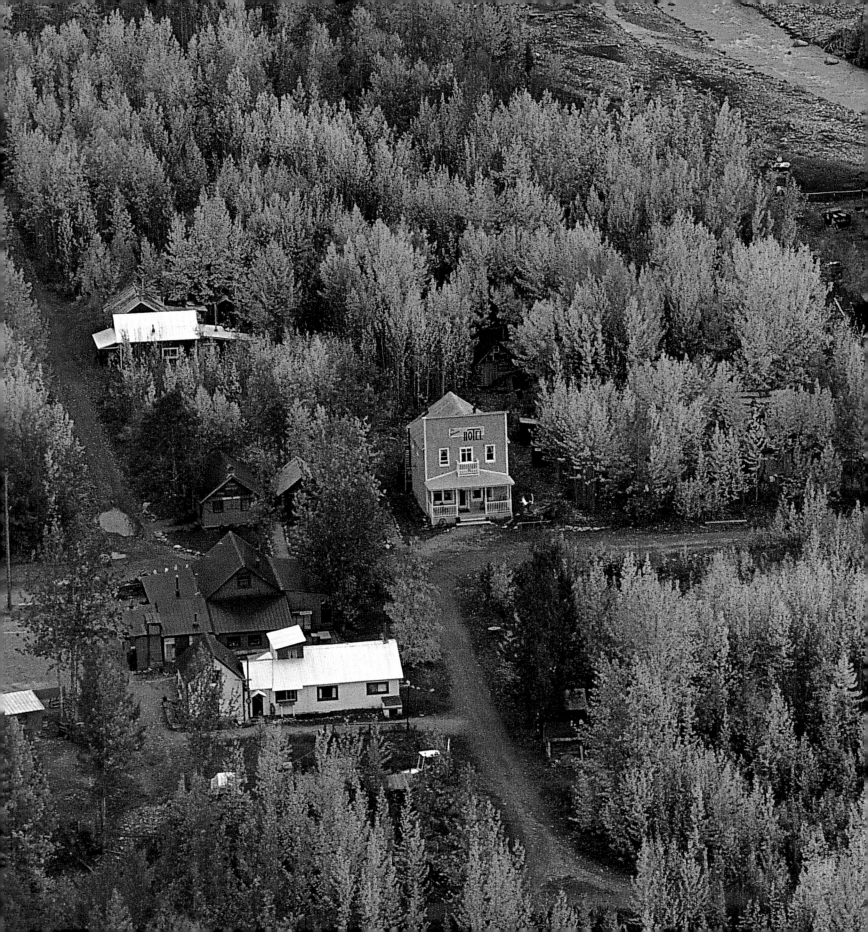

WRANGELL–ST. ELIAS
The View Ahead

National parks are required by law to be managed for preservation of the natural environment and for the enjoyment of current and future human generations. This presents a management challenge: preserve and use, a dual mandate. The question of how to maintain a wilderness and simultaneously make it accessible to people is a tough one, especially in the case of Wrangell–St. Elias National Park and Preserve, because of the balance that must be struck between retaining ecosystem integrity and at the same time supporting subsistence lifestyles, scientific investigations in botany, biology, and geology, and wilderness experiences for visitors now and in the future.

Many people will be content simply knowing that such a place as this exists; others will want to see it or travel in it, pitting their skills against its mountains, glaciers, rivers, and unruly weather. Those who have traditionally drawn their subsistence from what has become our largest park need assurance of their continued right to use parklands. Under federal law, local residents

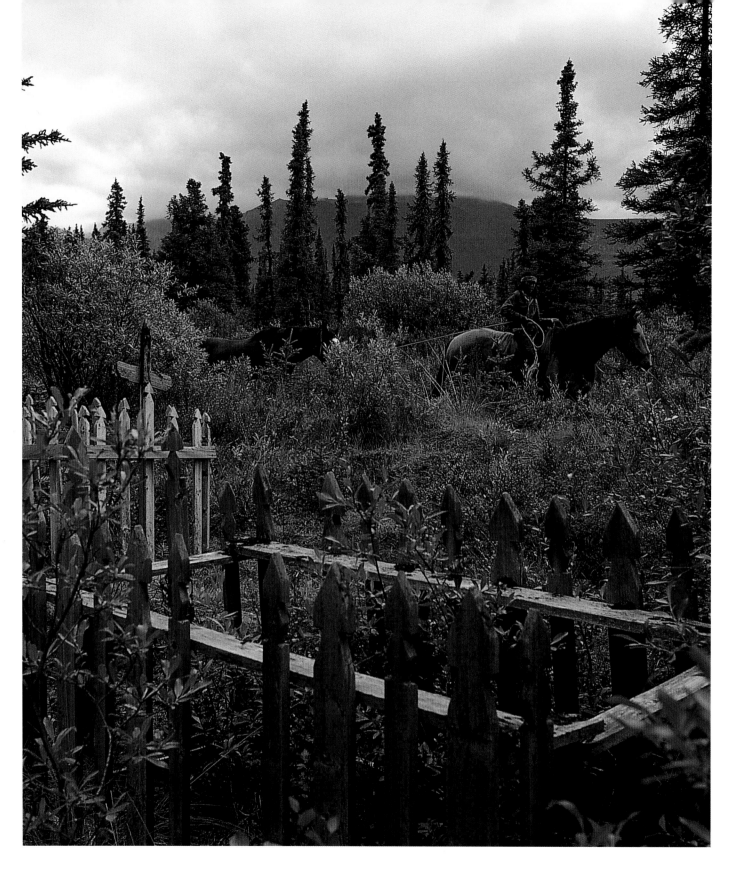

who have traditionally hunted or fished within what is now the park, as part of a subsistence lifestyle, are allowed to continue these activities. In practical terms, it means that residents of the small towns on the periphery of the park can hunt and fish there.

I discussed these subjects and needs with Jon Jarvis, superintendent of Wrangell–St. Elias, and asked him how the National Park Service planned to accommodate them. He outlined a variety of approaches the Park Service expects to take.

A steady upward curve in tourism is predicted as more and more people are drawn to the splendors of Wrangell–St. Elias. The Park Service will be installing some of the usual amenities: trails, picnic areas, toilets, interpretive sites. A visitor center is to be built at Copper Center, on a forested site overlooking the Wrangell Mountains and Copper River.

The state of Alaska owns the only two roads of any significance that penetrate the park. State and federal agencies will cooperate in developing these routes as scenic corridors and in improving the roads so they aren't quite the vehicle-maulers they are today. The 60-mile route from Chitina to McCarthy on the old railroad bed is narrow, bumpy, and seeded with railroad spikes. There are narrow places and blind curves. Two hours is the usual minimum travel time. The 42-mile stretch from Slana at the northern tip of the park to the end of the road near the tiny mining community of Nabesna needs upgrading too. A few commercial businesses are situated on private property along the Nabesna and McCarthy Roads and in McCarthy itself. The Park Service believes that private operators can help provide some services for the public while still respecting the integrity of the park.

The future will probably bring an integrated system of airstrips, trails, and cabins for use by backcountry visitors. Air travel offers the only workable way to make a territory that is so vast and mountainous accessible to backpackers, climbers, and others. The Park Service is working with air-taxi operators to identify existing airstrips and set up an information system for people planning to head into the backcountry. Systems of loop trails are planned along the McCarthy and Nabesna Roads and from selected airstrips. Plans call for renovating more than thirty historic cabins throughout the park for use by visitors.

Superintendent Jarvis helped me see challenges and potential solutions through the eyes of those responsible for managing this national treasure. He made it clear that plans for park development must fit within a framework of sensitive environmental protection. Trails and other access will be developed in a way that suits the land. I believe the plans for the future of this park are both practical and imaginative. It is comforting to know that a century and more from now, the park will still be here as a protected land. Given the pace of man's assault on nature,

◀◀ **Air view of the center of McCarthy in fall.**

◀ **A boy on horseback along the Nabesna Road passes an Indian gravesite.**

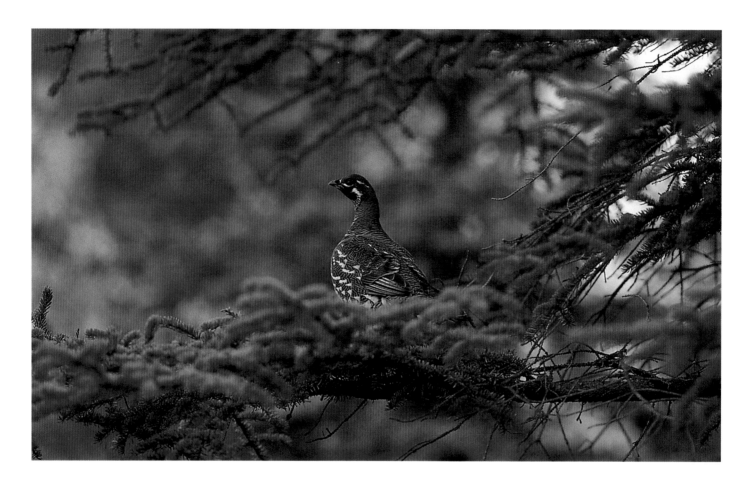

▲ A spruce grouse perches in a tree beside the McCarthy Road. Seemingly dull-witted birds, related to the ptarmigan, they are survivors. Often they will surprise a hiker by exploding from the ground directly ahead with very rapid wing beats, only to perch in a tree almost within reach.

such wild space will be needed even more desperately then than now. The creation of parks such as this one is a farsighted venture, an investment that can only become increasingly precious.

◆ ◆ ◆

The years have not been kind to the abandoned old mining town of Kennecott. The ravages of weather have damaged many buildings. Some have collapsed; others are rotting from water penetration after roofs lost shingles or tar paper. Kennecott Corporation contracted in 1956 with a salvage operator to raze the town. Copper wire, brass valves and fittings, and some remaining high-grade ore were taken, but demolition never proceeded very far.

The town eventually got new owners, and there were some attempts in the mid-1960s to mine more copper ore. A few houses in the town were subsequently sold off. A hotel was

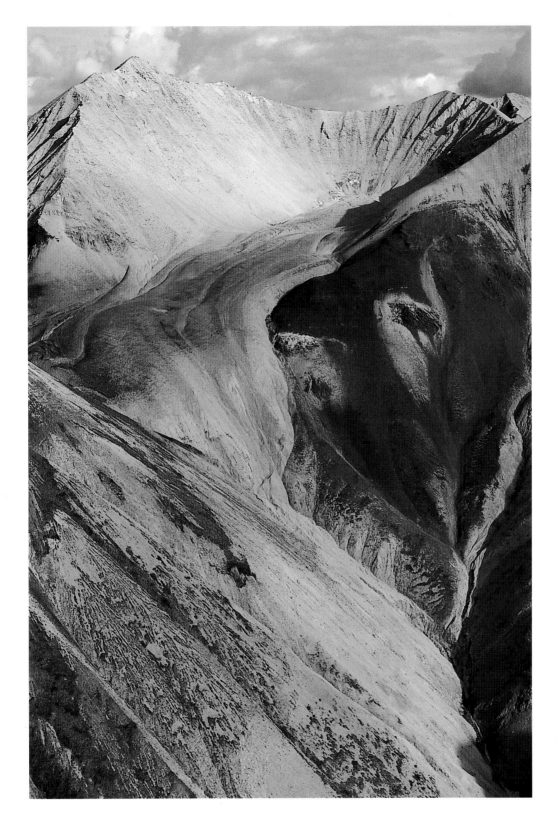

◄ Cirque and rock glacier near Nikolai Pass east of McCarthy.

► **The White River and Ping Pong Mountain east of McCarthy.**

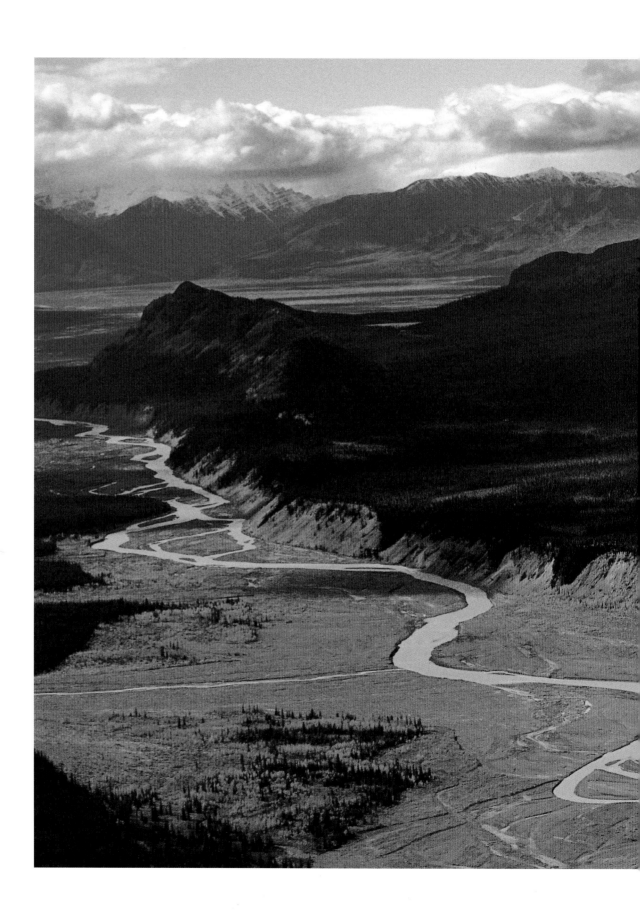

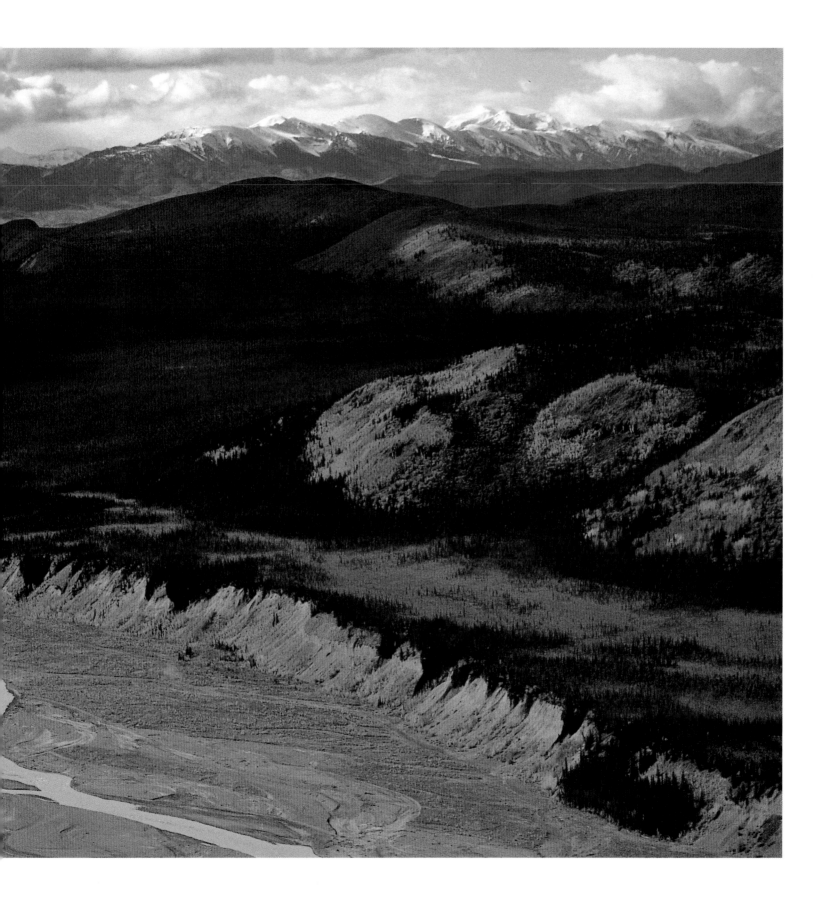

▶ Tent camping on the rim of Mile High cliffs, 4,000 feet above the Nizina River. Mount Bona and the Twaharpies are in the distance.

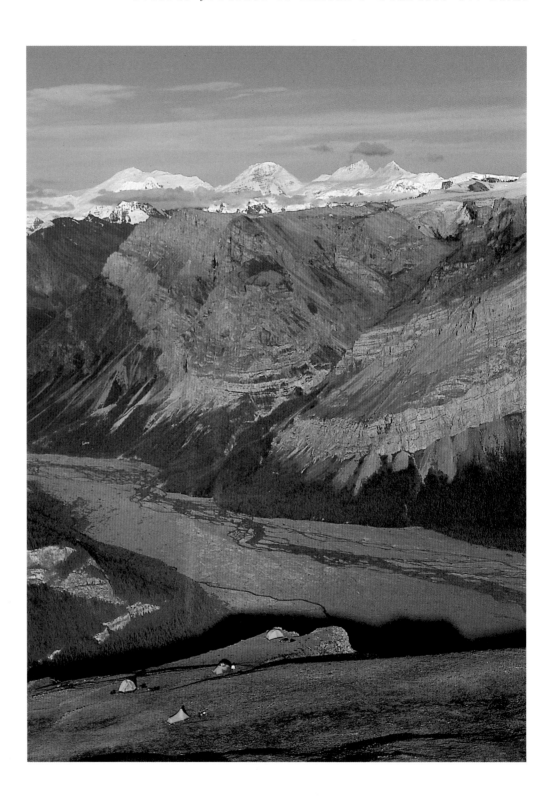

established in the building formerly known as the staff house, but it was destroyed by fire in 1983. Private enterprise is represented here today by Kennicott Glacier Lodge, successor to the ill-fated hotel. The National Park Service is looking into the possibility of eventually incorporating the town into the park itself. In the meantime, the old town rests, waiting to see what tomorrow brings.

In the years between 1954, when I first saw Kennecott in nearly pristine condition, to the present day, the town has both deteriorated and evolved. Throughout that time it was regarded as a source of parts, furniture, hardware, lumber, windows and doors—a community warehouse as it were. You can find bits and pieces of Kennecott wherever there are dwellings in this part of the country.

♦ ♦ ♦

The community of McCarthy has survived more than eight decades of change, and more is on the way. Perhaps nothing points the way toward change as much as the project to improve access to the town. No longer will people have only a hand-operated aerial tram for crossing the Kennicott River to get into town from the road system. The footbridge being built to eventually succeed the tramway seems modest enough—the bridge won't accommodate cars and trucks—but it marks another significant move toward the future. As the main settlement within Wrangell–St. Elias, McCarthy's fate also is bound closely to that of the national park, even though the town is not park property.

The tram symbolizes two aspects of life here: hard physical labor (it's tough work to get yourself and your freight across the river and into town) and romantic adventure (the tram crossing serves as a sort of magical looking glass like the one Alice stepped through on her journey into Wonderland). People and supplies can get into McCarthy by airplane, of course. The airport is just one bumpy mile from

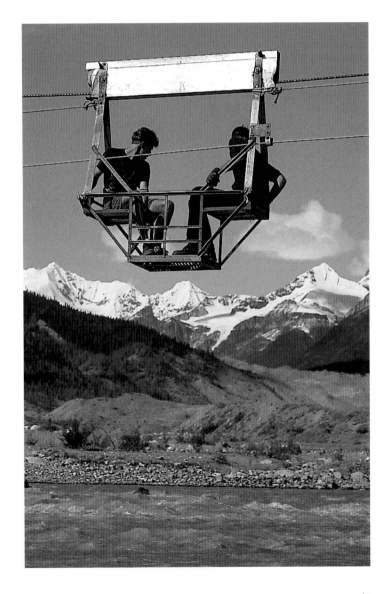

▼ **Boys crossing the west branch of the Kennicott River on the tram.**

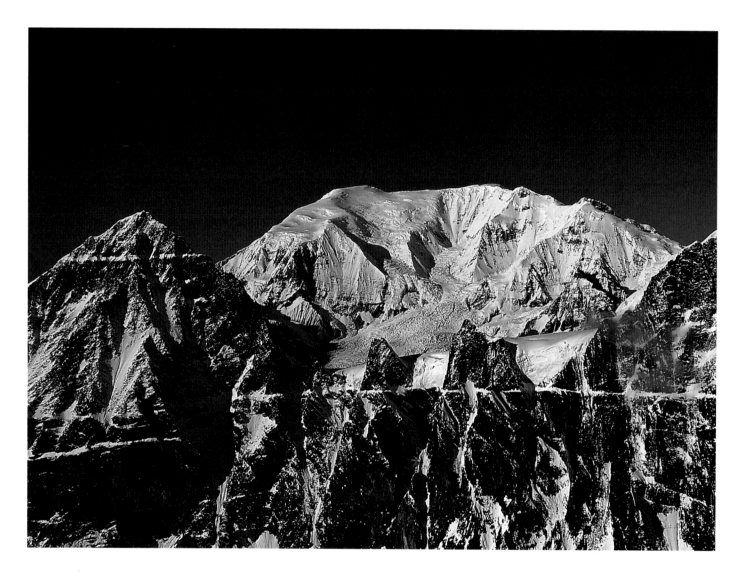

▲ **Mount Blackburn framed by the saw-toothed shoulder of Castle Peak.**

town. But it's amazing the amount of freight that comes in by tram: drums of diesel fuel and gasoline, cases of food, lumber, hardware, propane cylinders, personal belongings, bicycles, dogs, even all-terrain vehicles.

As for Alice's looking glass, consider this: when you leave your vehicle, you make the last leg of your journey into McCarthy via the tiny tram suspended above the glacial Kennicott River. You are projected into a new world. How you spend your time in this wonderland is up to you. You can rent a room, buy your meals, take a hot shower, have a drink or two. You can go on a sightseeing flight, climb on Kennicott Glacier, raft down the Kennicott River, or hike 5 miles up the

old road to Kennecott. You can explore McCarthy and perhaps some of the natural world beyond its boundaries. Or you can just find a quiet place and sit in the sun.

I came to know McCarthy by flying there from Chitina during the 1950s and early 1960s. A meal at McCarthy Lodge would give me a chance to ferret out all that had happened since my last visit. Often I'd end up helping with something that needed two sets of hands. I remember spending most of an afternoon with a sick, disassembled generator, trying to get it running again before

▼ **Moon over the Crystalline Hills on the McCarthy Road.**

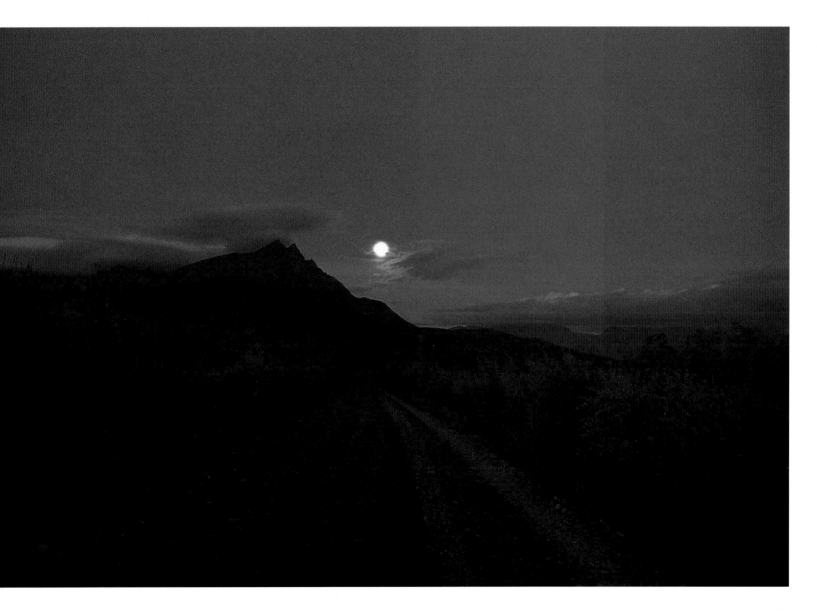

▶ **Now home to a willow shoot, a rusty ice-split pipe is filled with sand instead of the water it once carried at Kennecott.**

all the food in the freezer spoiled. One evening an airline pilot and I sat on the living room floor and rebuilt a defunct one-armed bandit so it could take people's money again. Some of mine disappeared during a test, I recall.

Today, only two of the people I knew in the 1950s remain in McCarthy. The one-armed bandit is gone. My family now has a small cabin in a quiet place where the rushing water of McCarthy Creek and the sounds of birds are mostly all we hear. Cabins are never finished, of course, so I always have something to do. We heat with wood, cook with gas, and haul our water from Clear Creek. We keep it simple so that much of our time can be spent reading or exploring or photographing.

As I contemplate the course of history in McCarthy over the years, I'm reminded of a small incident that helped me understand the town in a new and perhaps more accurate way. Peering out the McCarthy Air office door during a pouring rain, I noticed a truck slowly approaching. Just an ordinary McCarthy pickup truck, splashing slowly along, sort of tired and decrepit, the hood a color that didn't match anything else. As the truck hit a series of water-filled chuckholes, the hood flew several inches upward and slammed back down with a metallic clunk. The front fenders (also in unmatched colors) shook violently. Then the rear wheels took their turn. I had to laugh as the bed of the truck, together with the right side panel, stayed pretty much in formation with the front of the vehicle, while the whole left side, tailgate, and rear bumper seemed for a moment to have business elsewhere. They each made violent excursions in separate directions and then settled back into position as the vehicle finally left the holes behind.

McCarthy is something like that loose, mismatched old pickup truck. It rattles some and tries to fly apart, but it goes on working, and with a little care and patchwork it will continue to function. The town almost died during the quiet years after 1938, but despite time and wear, it's still here. Now and then it hits a chuckhole, but like the truck it will probably outlast us all.

Many old buildings and most old residents are gone from this historic community. Still, those who live here now—and their numbers are growing as they once did when there was a mine and railroad—are here for the same reasons, mostly, as those who inhabited the place originally. In the old days they mined the miners, today they mine tourists. Challenges to one's ingenuity, physical strength, skills, and imagination are part of living in McCarthy. Self-reliance is a must where supplies and help are so distant. Small communities everywhere have internal dissension and disagreements—after all, each person would like to see things done his or her own way—so reaching consensus is often a struggle. Yet the decision to build the footbridge across the river is an example of agreement reached out of the need to retain the identity of McCarthy as a

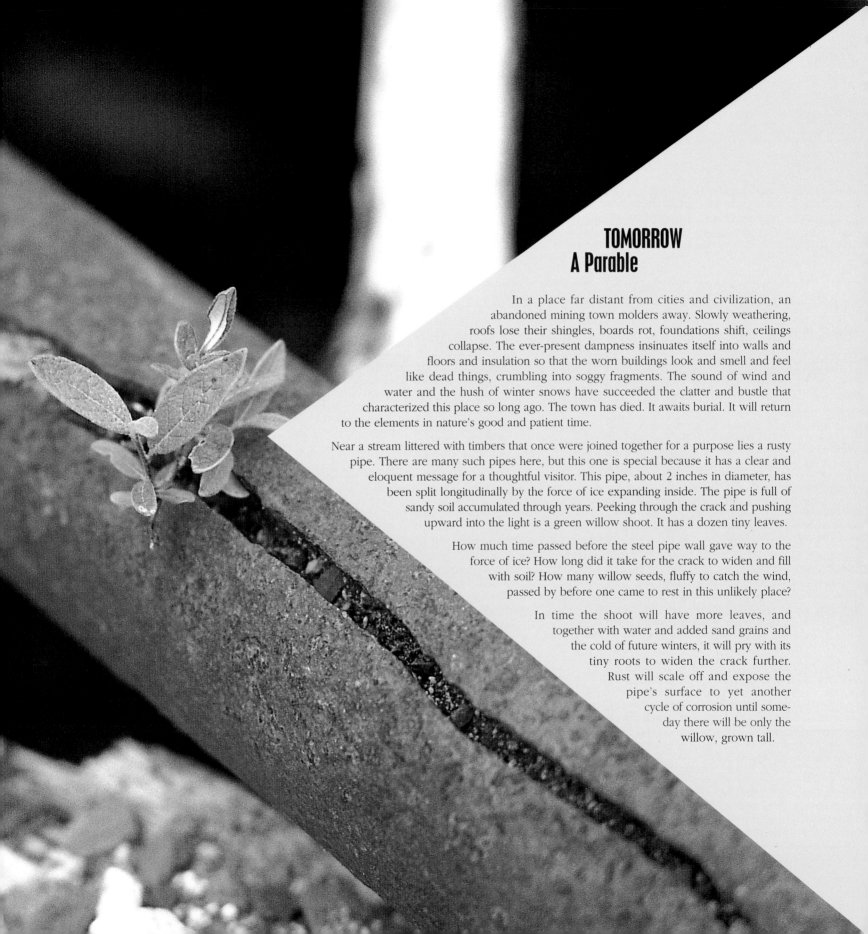

TOMORROW
A Parable

In a place far distant from cities and civilization, an abandoned mining town molders away. Slowly weathering, roofs lose their shingles, boards rot, foundations shift, ceilings collapse. The ever-present dampness insinuates itself into walls and floors and insulation so that the worn buildings look and smell and feel like dead things, crumbling into soggy fragments. The sound of wind and water and the hush of winter snows have succeeded the clatter and bustle that characterized this place so long ago. The town has died. It awaits burial. It will return to the elements in nature's good and patient time.

Near a stream littered with timbers that once were joined together for a purpose lies a rusty pipe. There are many such pipes here, but this one is special because it has a clear and eloquent message for a thoughtful visitor. This pipe, about 2 inches in diameter, has been split longitudinally by the force of ice expanding inside. The pipe is full of sandy soil accumulated through years. Peeking through the crack and pushing upward into the light is a green willow shoot. It has a dozen tiny leaves.

How much time passed before the steel pipe wall gave way to the force of ice? How long did it take for the crack to widen and fill with soil? How many willow seeds, fluffy to catch the wind, passed by before one came to rest in this unlikely place?

In time the shoot will have more leaves, and together with water and added sand grains and the cold of future winters, it will pry with its tiny roots to widen the crack further. Rust will scale off and expose the pipe's surface to yet another cycle of corrosion until some-day there will be only the willow, grown tall.

▼ **Old Ford truck wheel and new dandelions by the side of the road in McCarthy.**

unique place instead of just another "destination." The tramway, originally built to replace a succession of bridges that washed out, could no longer accommodate the growing number of users. But McCarthy and Kennecott could never deal with the scores of cars, motor homes, and other vehicles that would inundate the little towns if a highway bridge were to be built over the Kennicott River.

Whatever McCarthy is now, whatever it means to those who are charmed by its special

qualities—a little primitiveness, a little serenity, a glimpse of today's pioneers making their way in surroundings so beautiful you never can forget them—all that would vanish if the bridge marked just another river crossing and not the place where the road ends and Wonderland begins.

Longtime resident Loy Green said it best: "If there was a road to McCarthy, it wouldn't be here."

♦ ♦ ♦

In the early 1970s I flew with a friend in a single-engine plane from the Adirondack Mountains in New York State to the Grand Canyon in Arizona and back again. Mostly we flew at an altitude of 3,000 feet or lower. I had taken numerous transcontinental car trips, but those hadn't prepared me for what I saw during that low-altitude cross-country flight. Without exception, we were never out of sight of roads, bridges, steel mills, towns, pipelines, transmission lines, refineries, strip mining, clear-cutting, or other evidence of our species. The rate at which humankind can alter its habitat has expanded immensely through the years. We are the only animal who can do this, and we are forever honing our talents.

Experiences like these make me appreciate the worth of Wrangell–St. Elias and our other parklands.

Creation of the park in 1980 was controversial and still sparks intense argument. Some people feel that this park and others in Alaska constitute a "land grab" or a "lockup" on the part of the federal government. Recent years have seen a lessening of that hostility, but many people continue to view parks as unnecessary restrictions on their right to go where they please, do what they please, and use what they please for pleasure or profit. I see this park as a place set aside and protected from human depredation, where we can experience solitude and silence and beauty, where instead of overwhelming nature, we can be overwhelmed.

The creation of Wrangell–St. Elias did take a number of interests into account. Hunting is permitted in some areas, private mining claims still exist, and the park surrounds several substantial pockets of state and private land. That's why you'll see a section of clear-cut forest along the road to McCarthy: it's on private land. This reminds me of Conrad Richter's novel *The Awakening Land,* which tells of a woman and her family who, together with other settlers, cleared great sections of old-growth deciduous forest that shut out the sun and hindered homesteading. Then, in her old age, she began *planting* trees. Her affinity for the natural world had not left her. It had simply been set aside in adversity while she and her neighbors did what nearly all westward-thrusting pioneers did: modify their environment so they could live in it. Yet in the end she yielded to a need as great as the one that compelled the destruction of forests in her youth: the need for some natural thing, some living fragment as a reminder that the wild world was an irreplaceable part of her spirit.

Once as I argued these issues with a friend, he claimed that revegetation and reforestation can heal the scars we leave in our wake. He cited the fresh green of regrowth in clear-cuts in the Pacific Northwest and said that in a short time new forests would present a beautiful scene. When

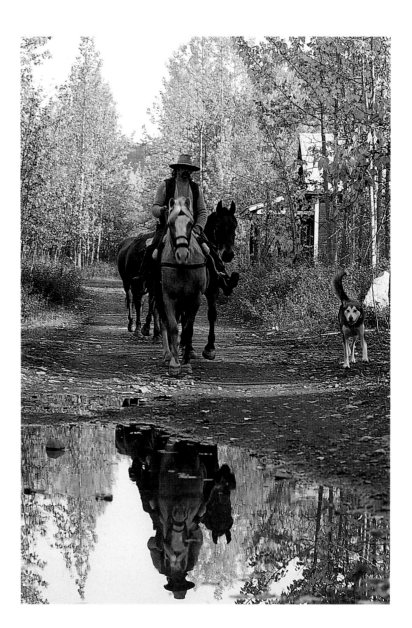

▲ **McCarthy resident John Adams returns to town with his packhorses after a successful moose hunt.**

▶ **A red fox on the McCarthy Road gazes at the camera and licks its nose.**

▼ **Lichens and sphagnum moss on the forest floor near McCarthy.**

I pointed out that it still takes 900 years to grow a 900-year-old tree, he looked at me as if I had lost my sense of proportion. Maybe I have.

Memory takes me back to a time when many of my evenings were spent in a canoe on an Adirondack lake, listening to sounds of the woods: a twig snapping under a deer's foot, the songs of peeper frogs, an owl hoot or a loon call, or the sound of high-flying geese traveling toward night and a place to rest before going on. My parents placed me at the threshold of the wild world and invited me to venture across. Thanks to them, I possess a gift beyond measure or telling. We must likewise pass it on. Values that embrace a respect for the wild world might be stated as follows:

Declaration of Dependence

Wilderness depends upon our forbearance, our care, and our farsightedness for its existence. Lives of wild creatures are in our hands; we hold the power of life and death over them. We declare that wilderness is essential to us; that neither wild things nor ourselves can live in isolation from one another; that our well-being, physical and spiritual, depends upon our making a commitment to the well-being of lives other than ours so that our own may be enriched by their presence.

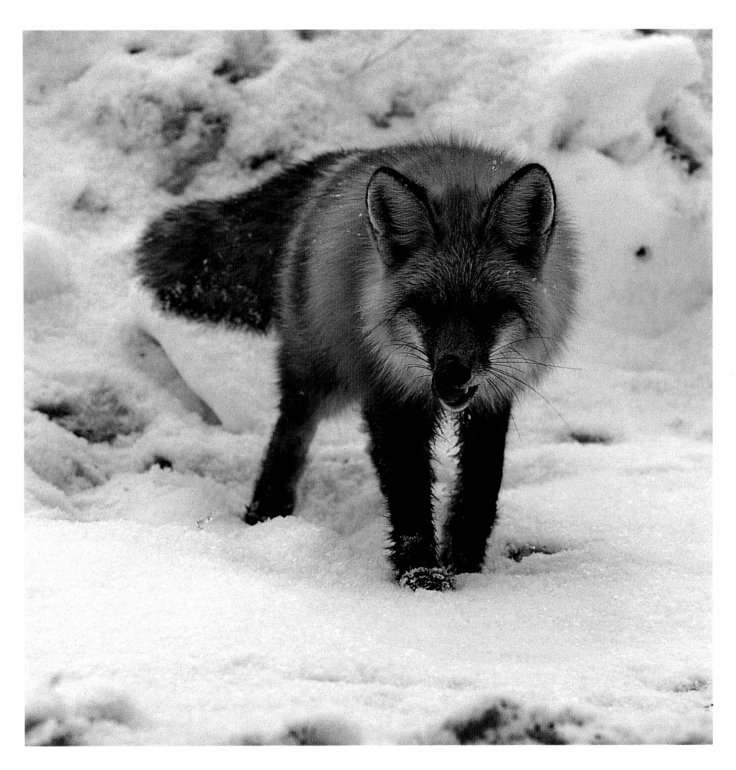

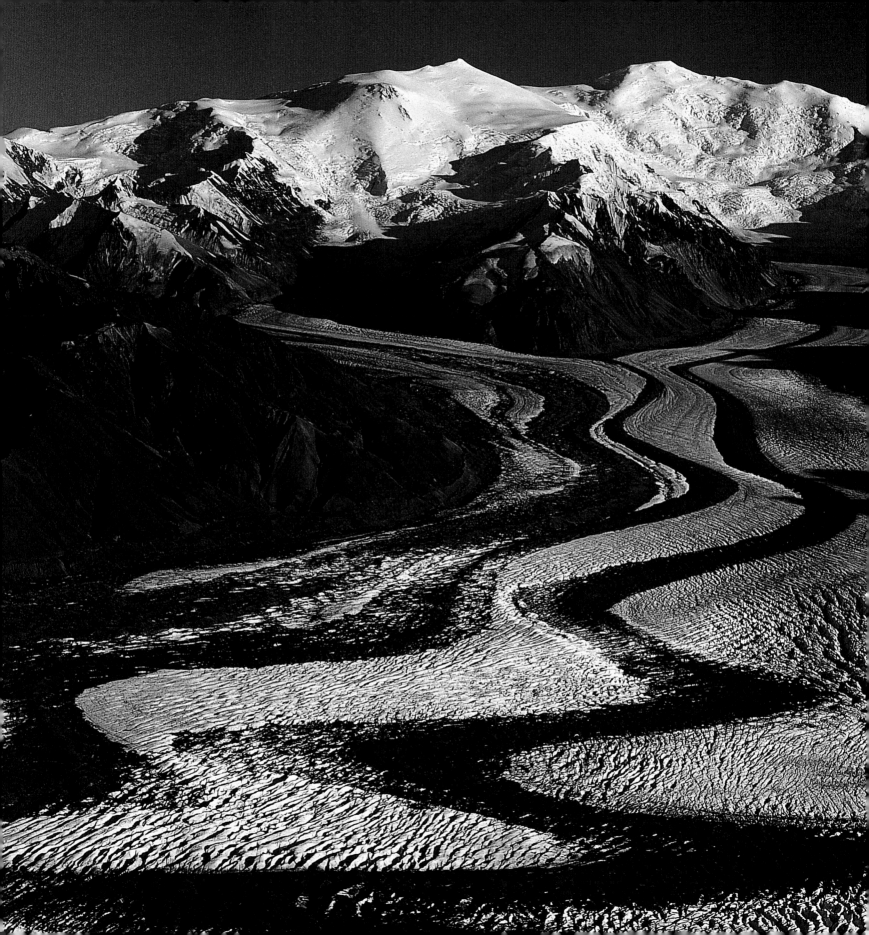

PORTFOLIO
The Far Country

For everyone who has made a career in photography, there was a starting point. Mine was the Wrangell Mountains. Pictures I made there in 1954 were shot with my first camera. My work as a photographer has taken me to many places in the world, but no landscape holds the compelling fascination for me that I found in the Wrangell and St. Elias mountain ranges.

Most of my photographic life has been spent making pictures for others; this book and its images were made for me. These superlatively grand surroundings have become for me a kind of spiritual refuge. I seem to belong to this place and its enduring beauty.

◄ **Mount Churchill and Mount Bona, part of the St. Elias Range, form a backdrop for Russell Glacier. Mount Churchill, a dormant volcano, erupted violently about 1,500 years ago, ejecting at least 12 cubic miles of ash, which can still be seen in the White River valley and along the Alaska Highway. The volume of material ejected was much greater than that of the 1912 Katmai eruption.**

Inset: Prickly rose (Rosa acicularis) at McCarthy. In early summer these roses bloom by the thousands along stretches of the McCarthy Road, filling the air with perfume.

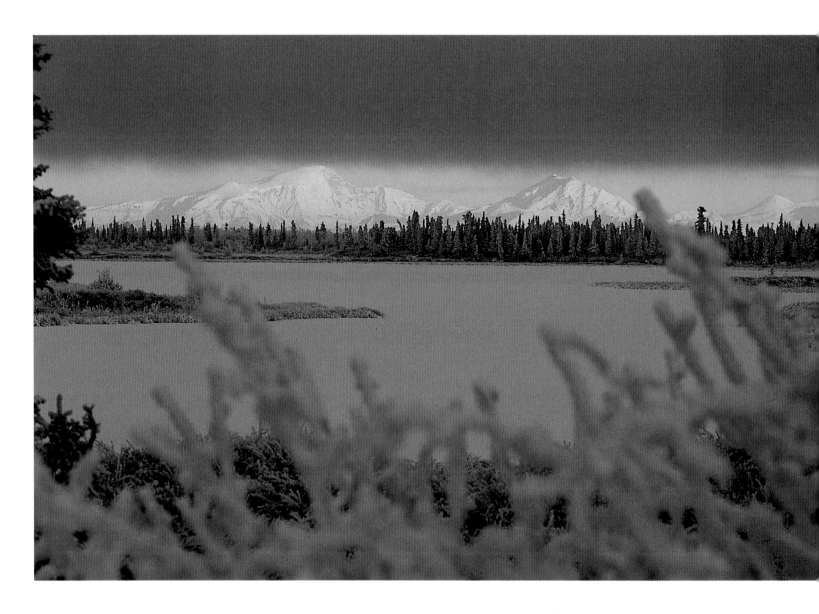

▲ Late on a winter afternoon three of the principal peaks of the Wrangell Mountains are seen from the Glenn Highway beneath a solid cloud deck. From left to right they are Mounts Sanford, Drum, and Wrangell.

In 1980, this vast and pristine wilderness became Wrangell–St. Elias National Park and Preserve. At more than 13 million acres, it's the largest national park in the United States, the equal of six Yellowstones. Nine mountains in the park rise above 14,000 feet, with four of them reaching higher than 16,000 feet.

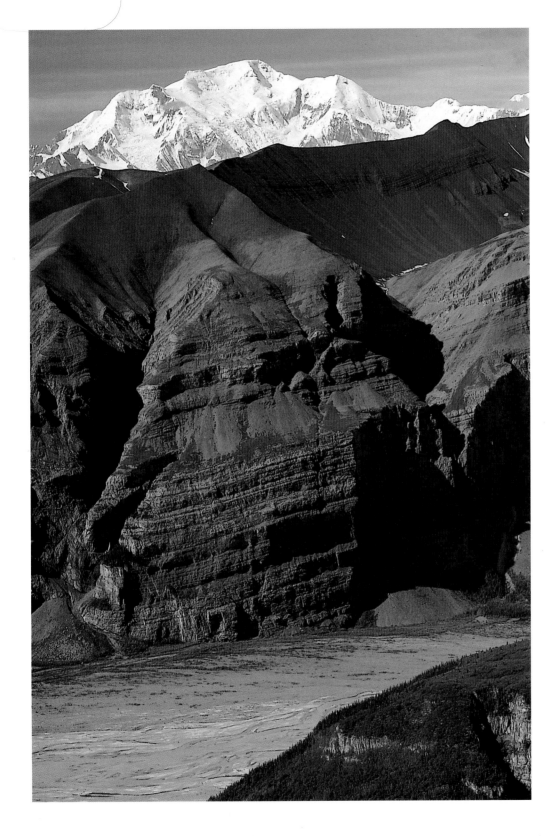

◄ Limestone cliffs form a wall along the Nizina River near its confluence with the Chitistone River. Locally called Mile High, the cliffs vary in elevation and are close to a mile in height in some places. Mount Blackburn is in the distance.

► Two large rock glaciers in the triangle bounded by the Nizina and Chitistone Rivers and Skolai Creek. Mounts Churchill (left) and Bona are in the background.

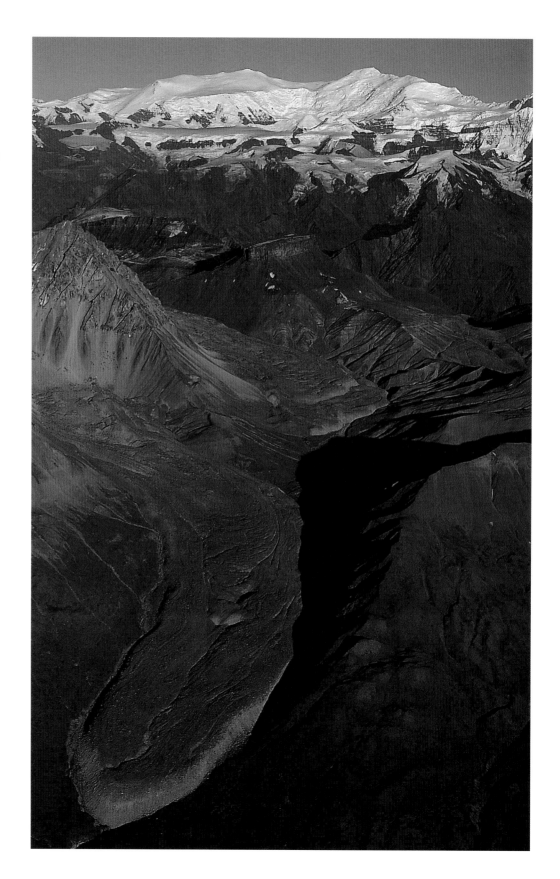

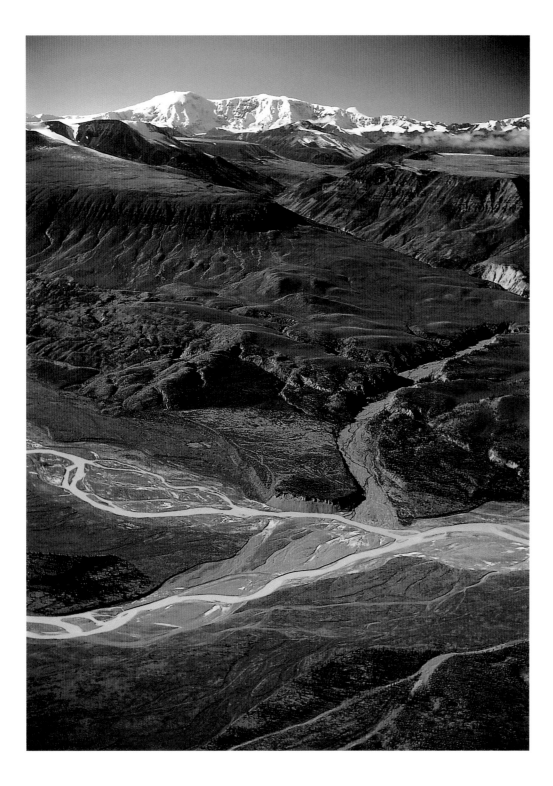

◄ Mesa Creek and Mount Jarvis. Jarvis is a major peak in the Wrangells, but is visible from only a few locations. The Copper River heads between Mount Jarvis and Mounts Wrangell and Sanford.

▶ As a summer storm clears, this unnamed mountain near Castle Peak unfolds its own temporary cloud system.

▶▶ Ogives below Stairway Icefall on Root Glacier near Kennecott. Ogives are often formed when a glacier flows down a steep, narrow icefall. One theory says that because of an increase in velocity in an icefall, the ice stretches and is exposed to more intense ablation in summer than in winter when it is blanketed with snow. This results in a seasonal fluctuation in thickness. There are several types of ogives and they are imperfectly understood.

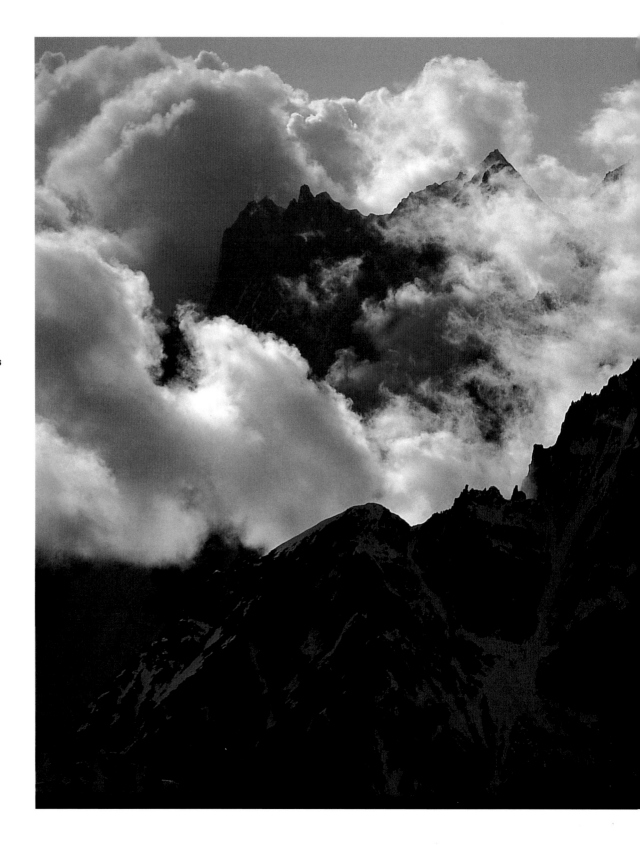

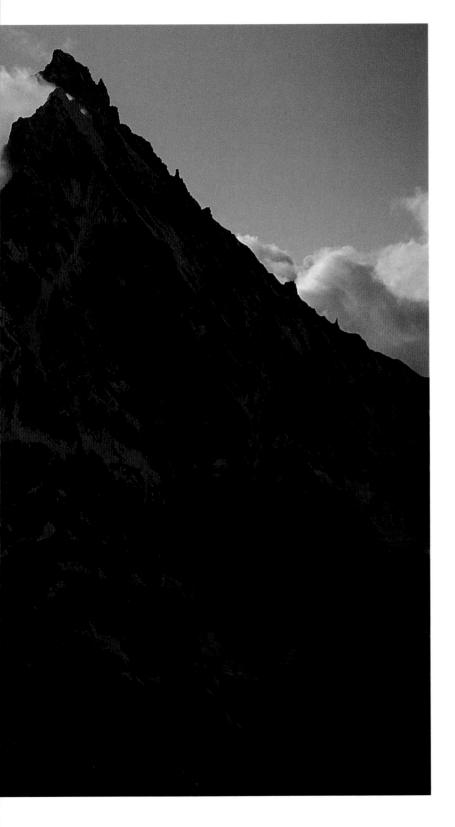

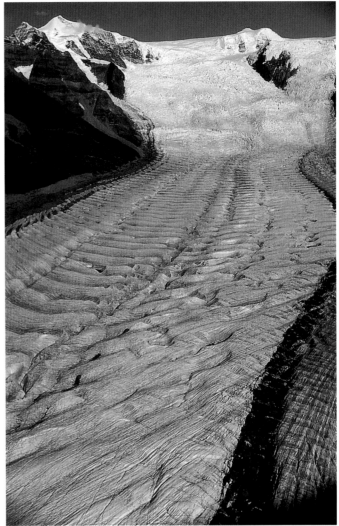

Photographs, powerful and telling as they may be, still fall

short of the personal experience of seeing this mighty land.

On many flights I find myself viewing some particularly spec-

tacular scene and saying, "Oh, wow, I have to look carefully

so I can remember!" There's an awful lot of "oh, wow!" in my

13-million-acre backyard.

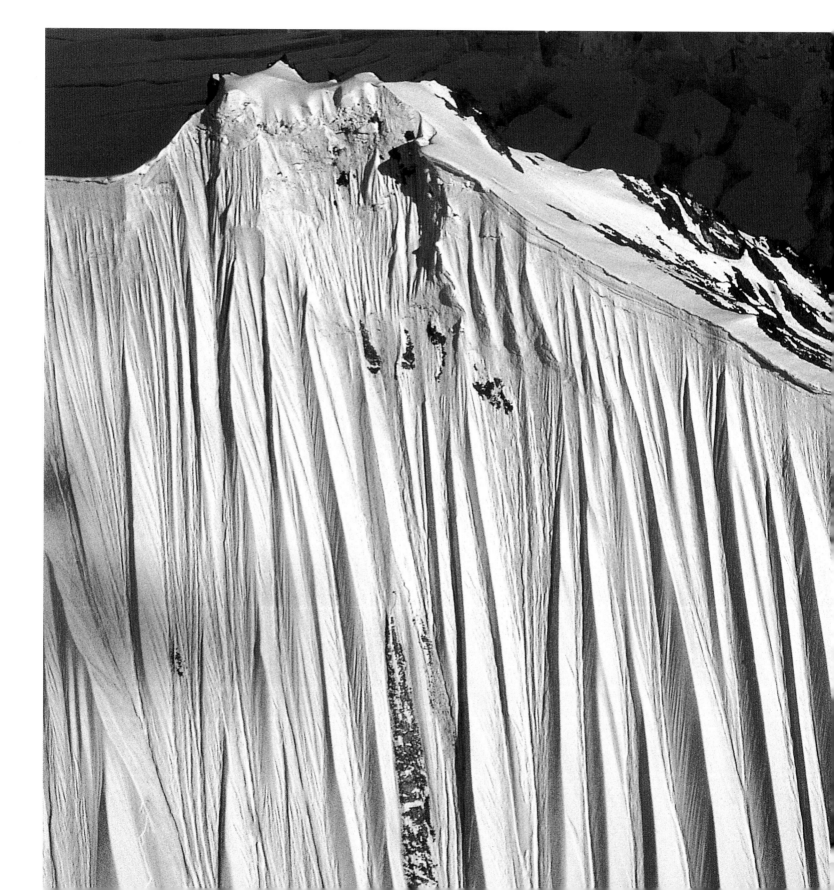

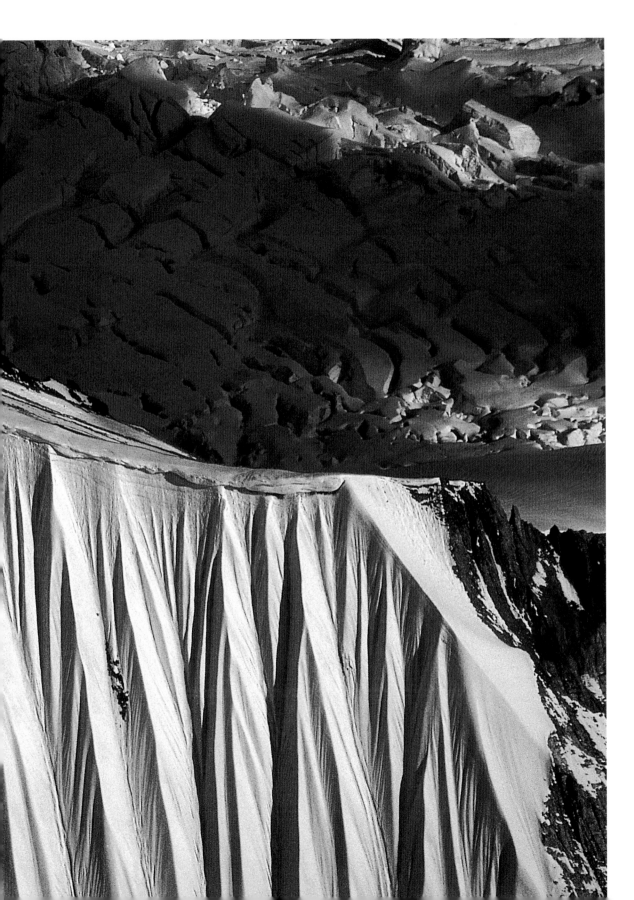

◄ Snow striations on an unnamed mountain near Castle Peak, west of McCarthy.

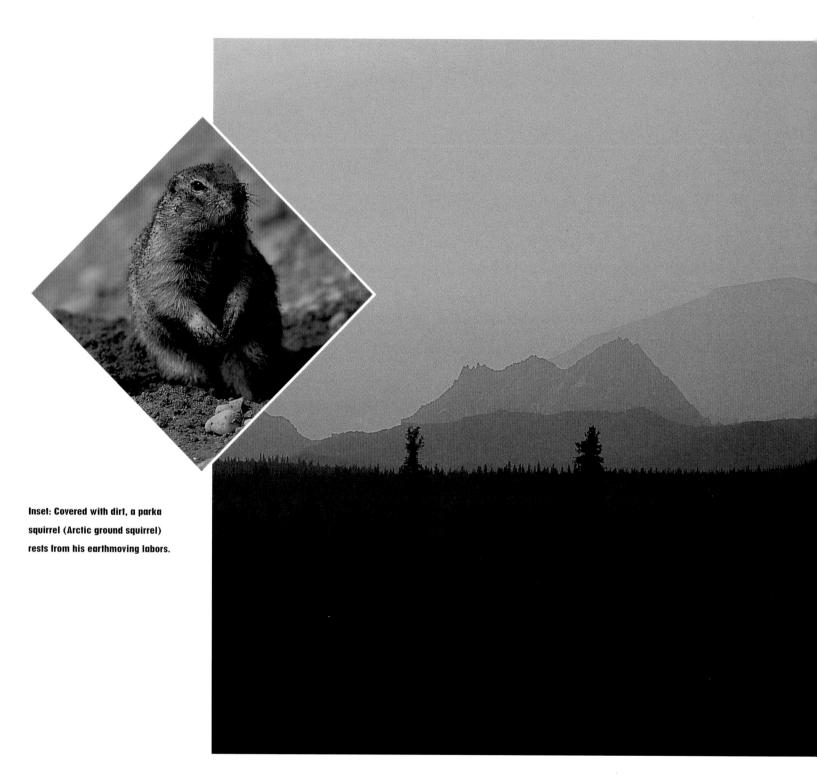

Inset: Covered with dirt, a parka
squirrel (Arctic ground squirrel)
rests from his earthmoving labors.

◄ Sunset sky illuminates
Mount Blackburn and foothills
seen en route to McCarthy.

► Mouth of the Chitistone River where it discharges into the Nizina River. The "goat trail" on the upper Chitistone is a popular hiking area.

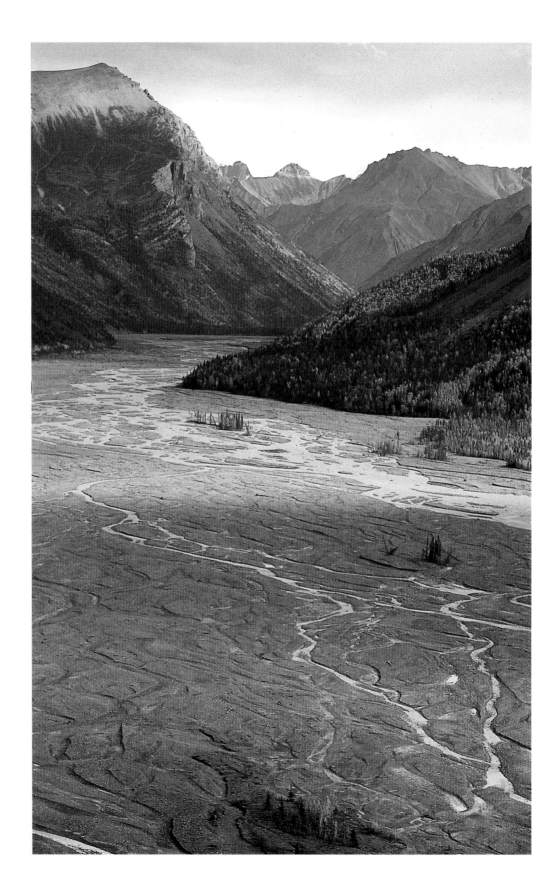

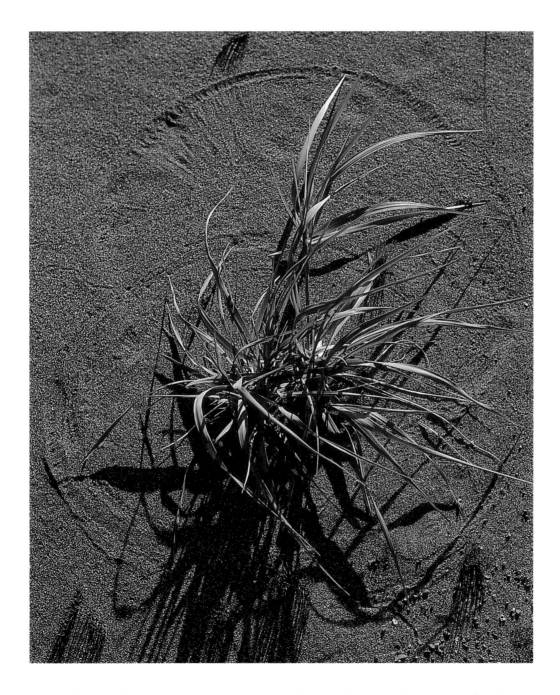

◀ **Windblown grasses inscribe a circle on the sand at Kageet Point, Icy Bay.**

As I'm flying, I often dream my way into pretty places as they pass below, imagining how it would be to live there. I have little dream cabins all over these mountains.

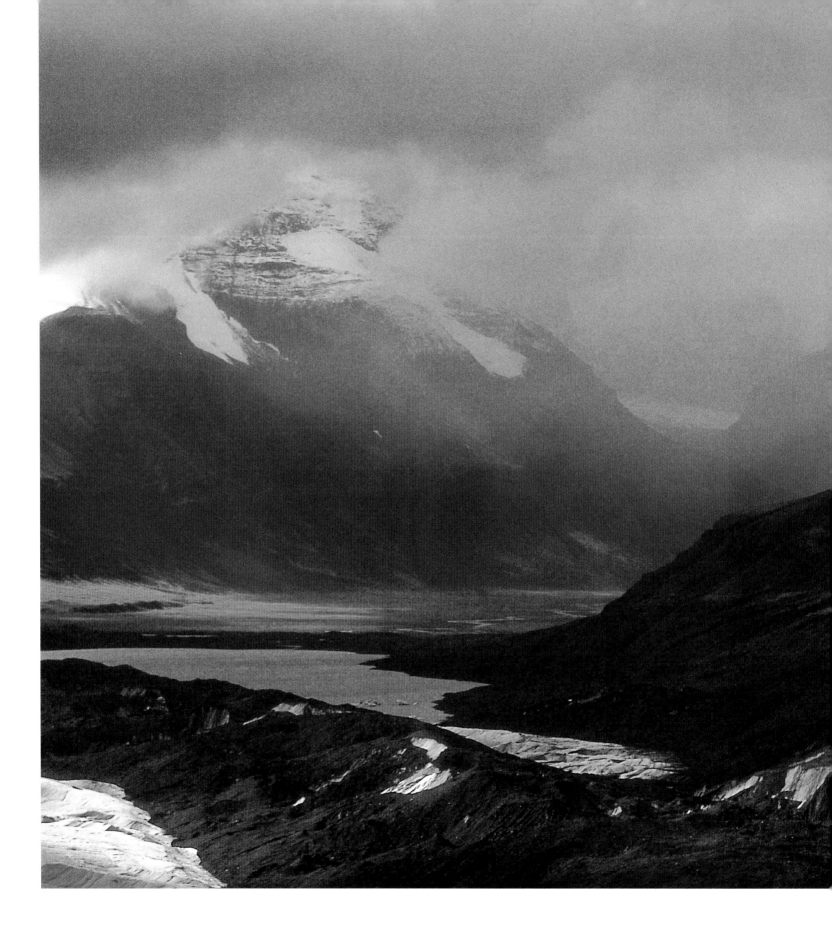

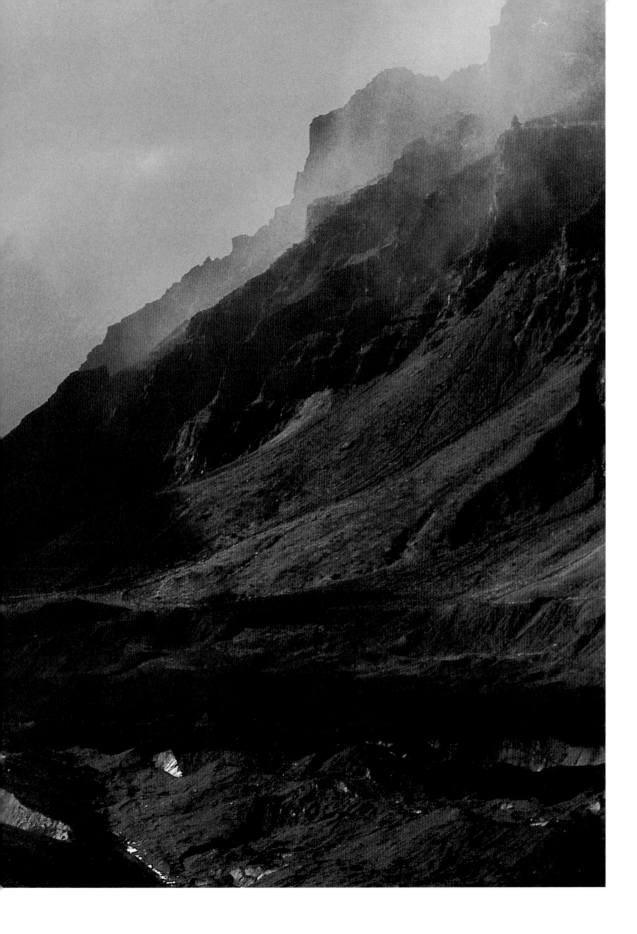

◀ Skolai Pass seen from above Russell Glacier on a stormy, turbulent day. This location is a favorite drop-off for climbers and hikers.

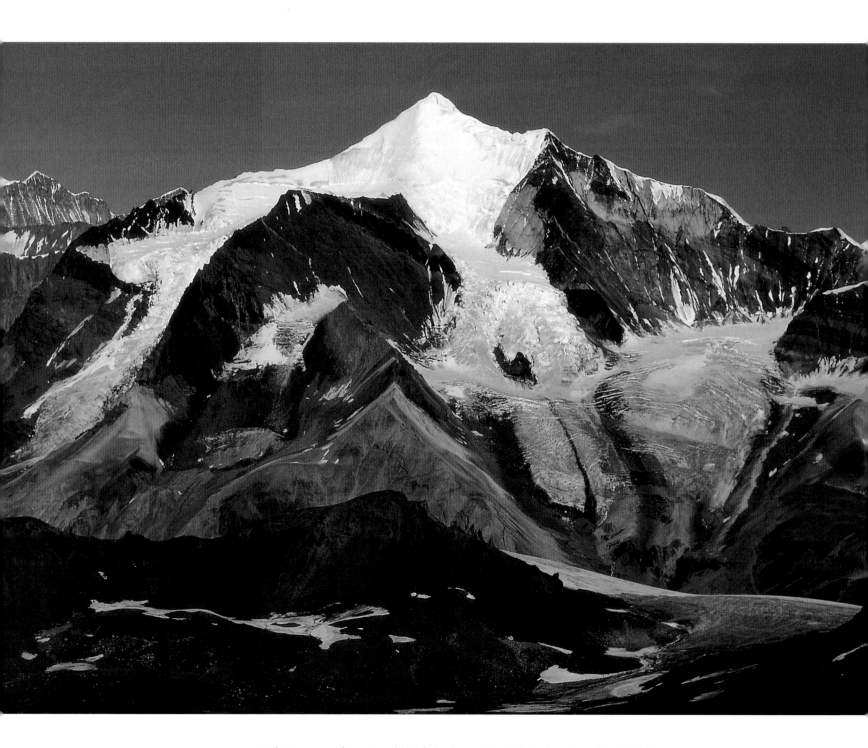

What you see here stands high in the ranks of this planet's splendid things.

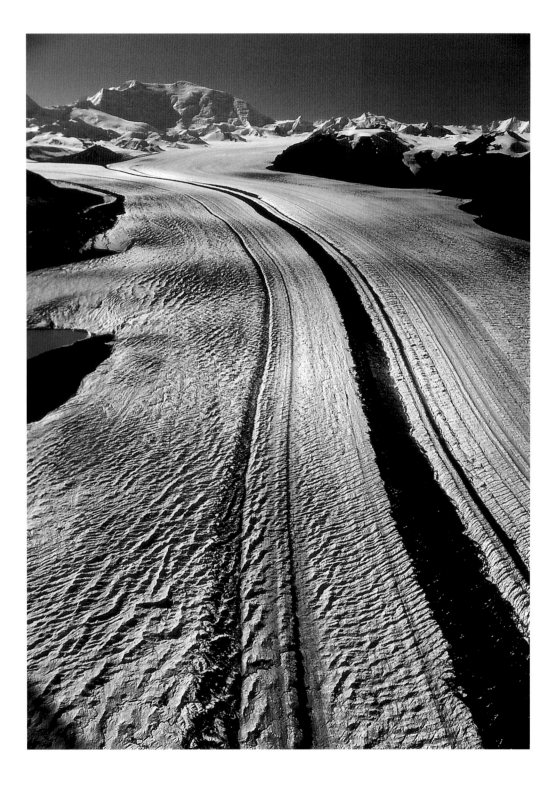

◄◄ Frederika Mountain. In summer this black and white and gray peak stands out among the mountains north of Skolai Creek.

◄ Nabesna Glacier on the north side of the Wrangells is one of the largest valley glaciers that terminates on land in Alaska. It originates on the slopes of Mount Wrangell and drains the central Wrangells. Mount Blackburn is a prominent landmark visible here near the point where the glacier turns north.

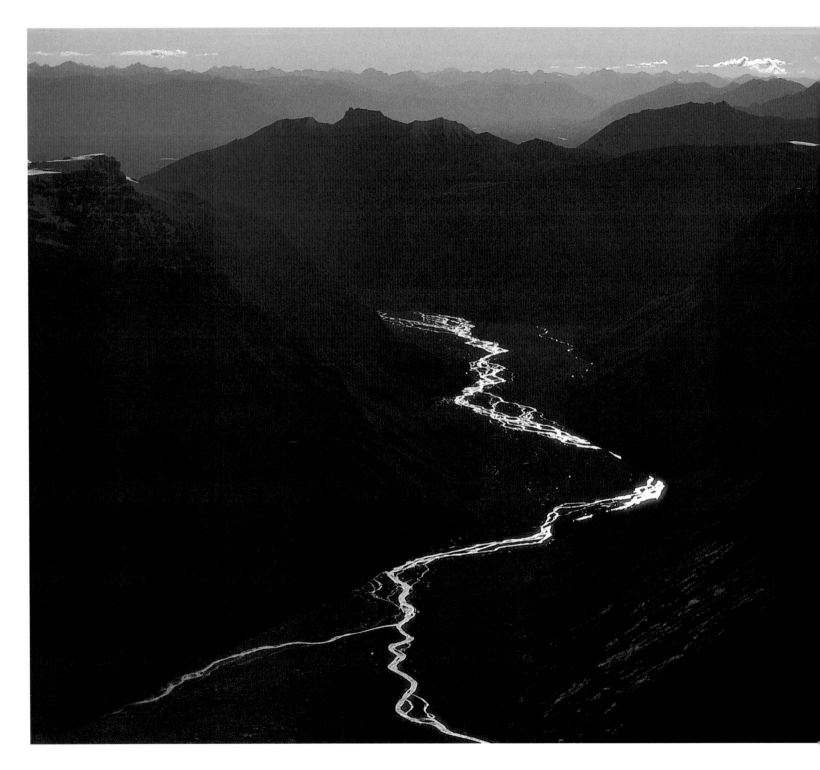

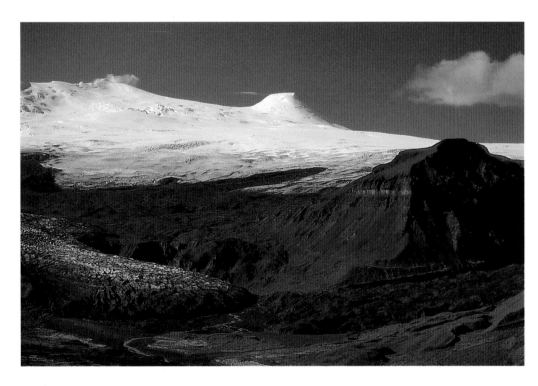

◀◀ Chitistone River on its way to join the Nizina River.

◀ Mount Wrangell crater emits a faint steam plume. Mount Zanetti, a cinder cone, perches like a tooth on the smooth flank of Wrangell.

▼ Yahtse Glacier, the Karr Hills, and an ice-filled arm of Icy Bay form a foreground for Mount St. Elias, at 18,008 feet the highest mountain in Wrangell–St. Elias National Park and the fourth highest in North America.

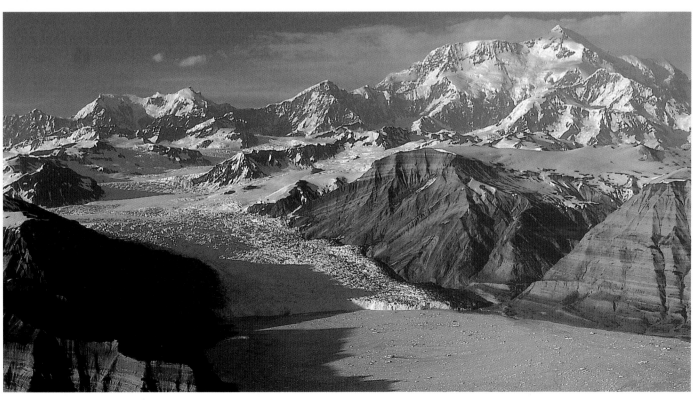

In fall, rain drenches the world. The sun appears, slanting

through a slot in the gray afternoon clouds, touching the

changing willow and aspen leaves with orange and setting

off crystal sparkles on branches.

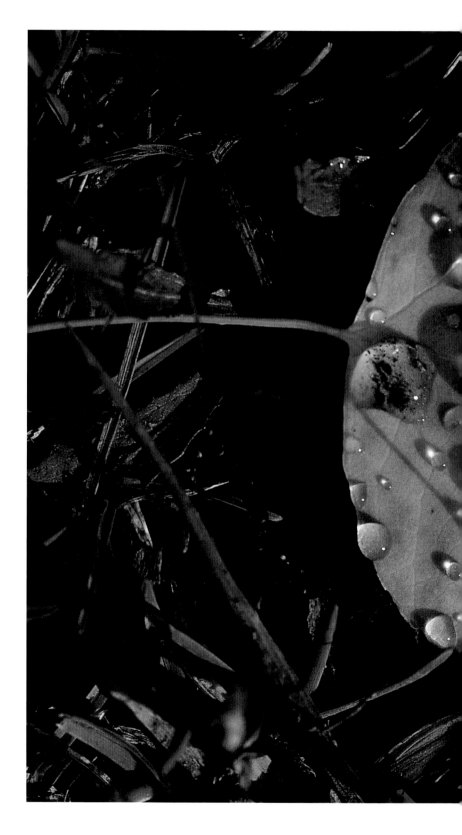

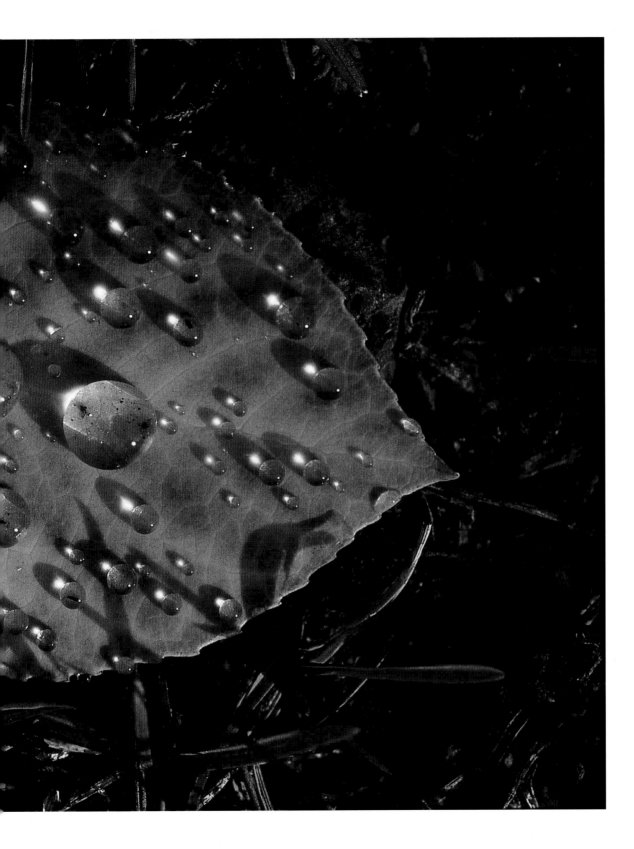

◄ Near McCarthy, a fallen aspen leaf forms an orange saucer for raindrops.

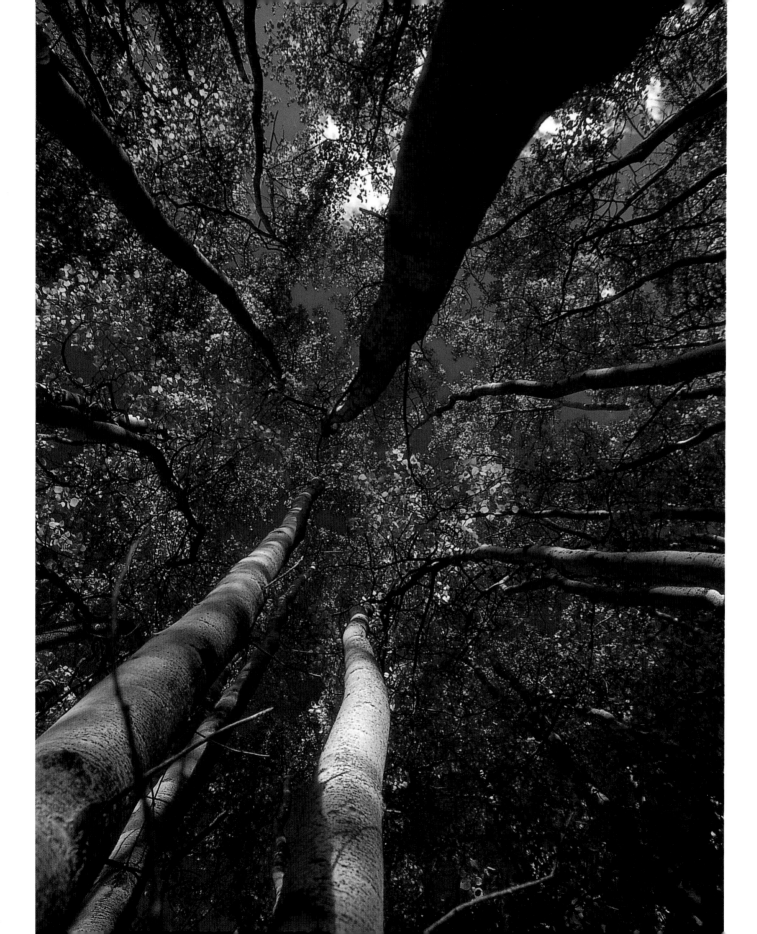

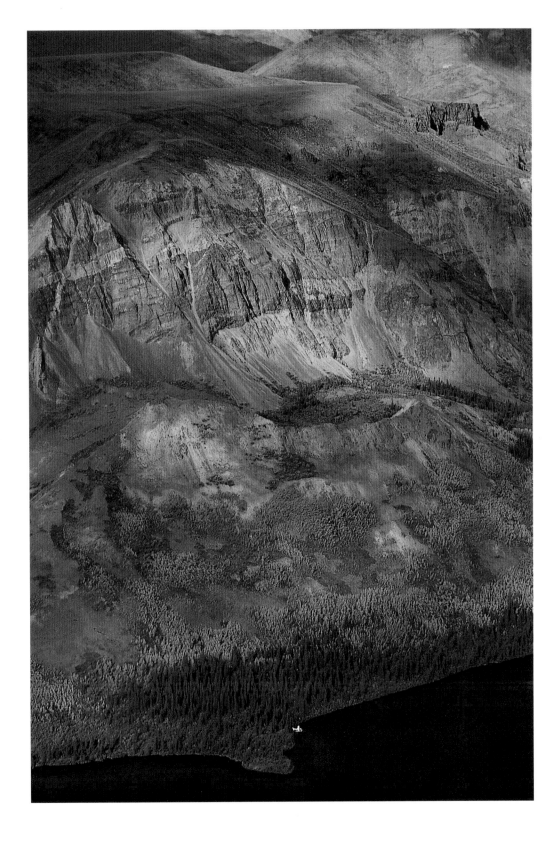

◄◄ A stand of aspens near the McCarthy Road presents a grand display of fall color.

◄ A floatplane roosts at a tiny point on Rock Lake in the White River valley.

▶ A look through an abandoned truck window shows the remains of the Bremner gold mine in the Chugach Mountains south of the Chitina River valley.

▶ ▶ McCarthy and McCarthy Creek with the Kennicott and Root Glaciers and Donohoe Peak in the distance. Donohoe Peak was the site of the Regal Mine (not associated with Kennecott). Miners and their equipment were transported using horses to cross the Root Glacier below the Kennecott Erie mine.

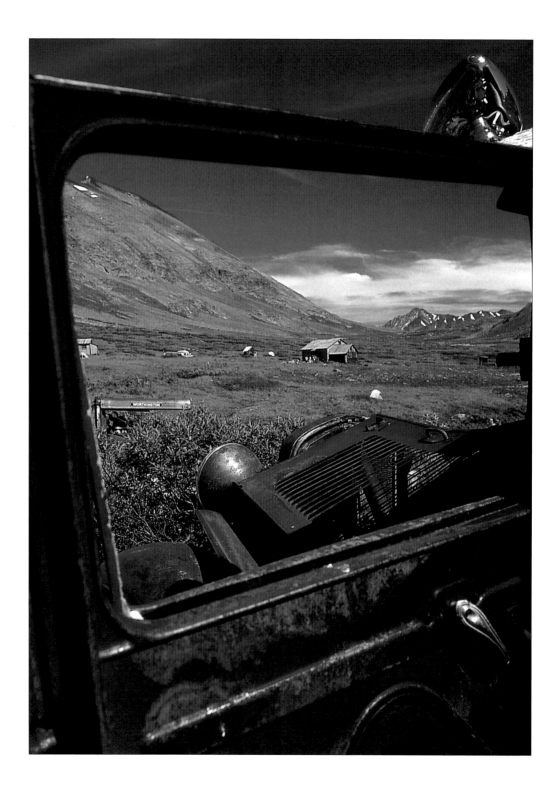

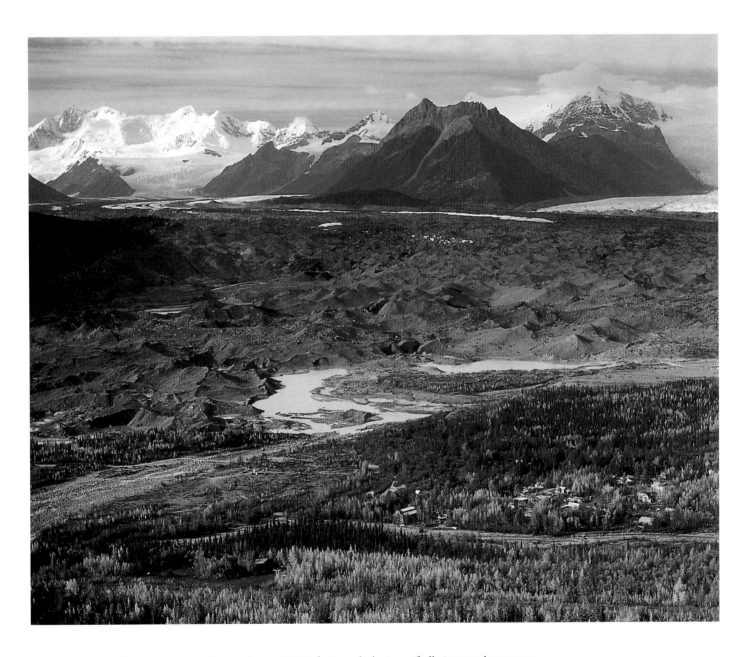

Lakes, forest, alpine tundra, ice-clad peaks to 18,000 feet, and glaciers of all sizes and patterns

dominate the specks of man's imprint in the form of ghost towns and tiny settlements. The

scene is a visual feast. The geology and human history are enthralling.

▶ **Mount Sanford looms above a snowy winter scene from the Glenn Highway.**

▲ The former gold rush town of
Chisana (pronounced Shushanna)
on the north side of the Wrangells
has a handful of residents now.
There is no road to Chisana.

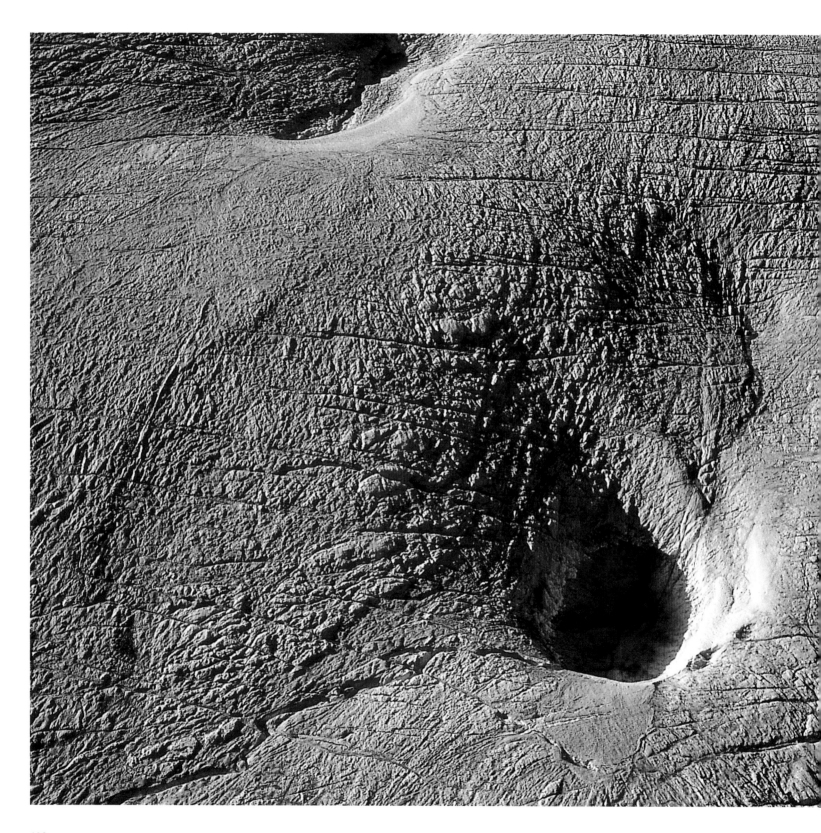

◄ Tiny blue pothole pond on the textured surface of Kennicott Glacier.

▶ In 1960 the Kennecott Jumbo Mine bunkhouses were beginning to tilt. By 1996 only one was still standing.

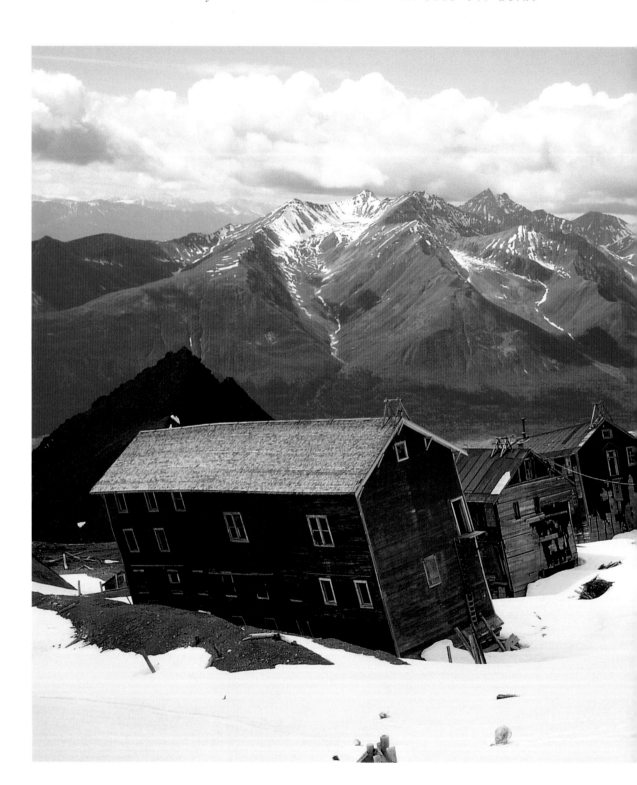

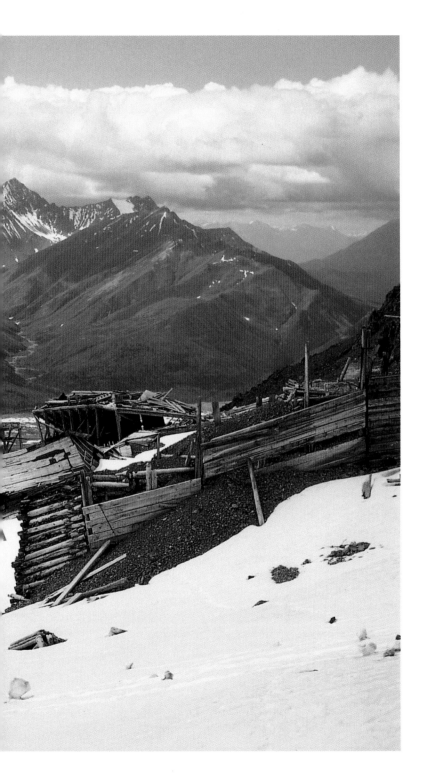

In Kennecott, it became obvious that the mines would eventually run out of profitable copper ore and one day close permanently. That day came in 1938. The mines closed, and the people of Kennecott packed up and left. On November 14, 1938, train service was discontinued. With the coming of winter, the silence of wilderness gradually enfolded the town.

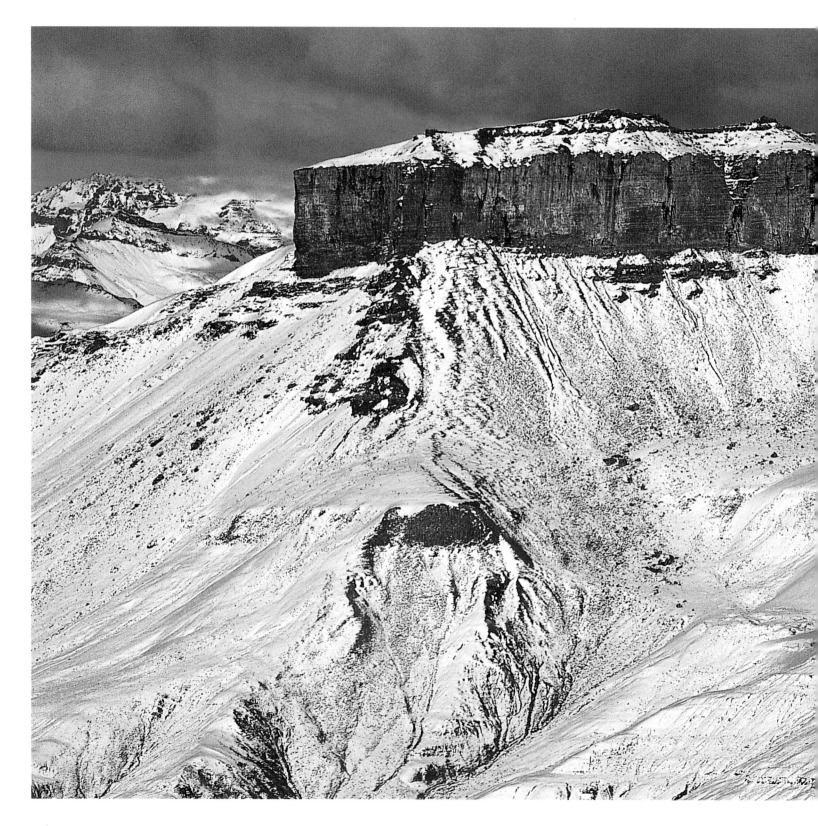

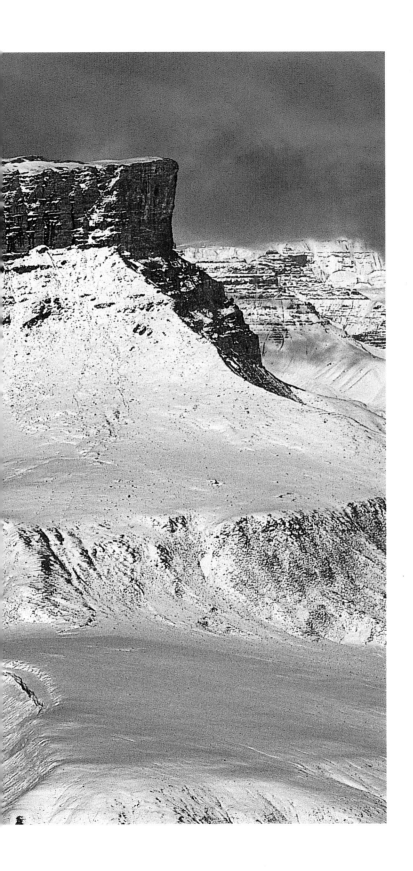

◀ **Snow textures a vertical-walled butte north of the Chitistone River.**

▼ **Kennicott Glacier and Donohoe Peak.**

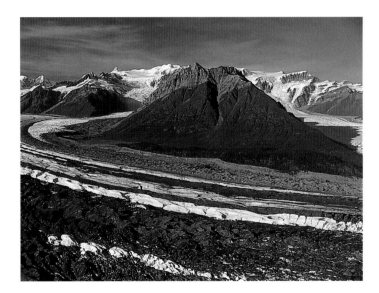

When I first set foot in the deserted mining town of Kennecott, I came into intimate touch with an era that had a sharp but transitory impact on the landscape. The mines had their day, but the mountains remain.

▶ **Waterfall on Mile High cliffs along the west side of the Nizina River valley.**

▶ ▶ **Mount Natazhat and Mount Sulzer form the south wall of the White River Valley.**

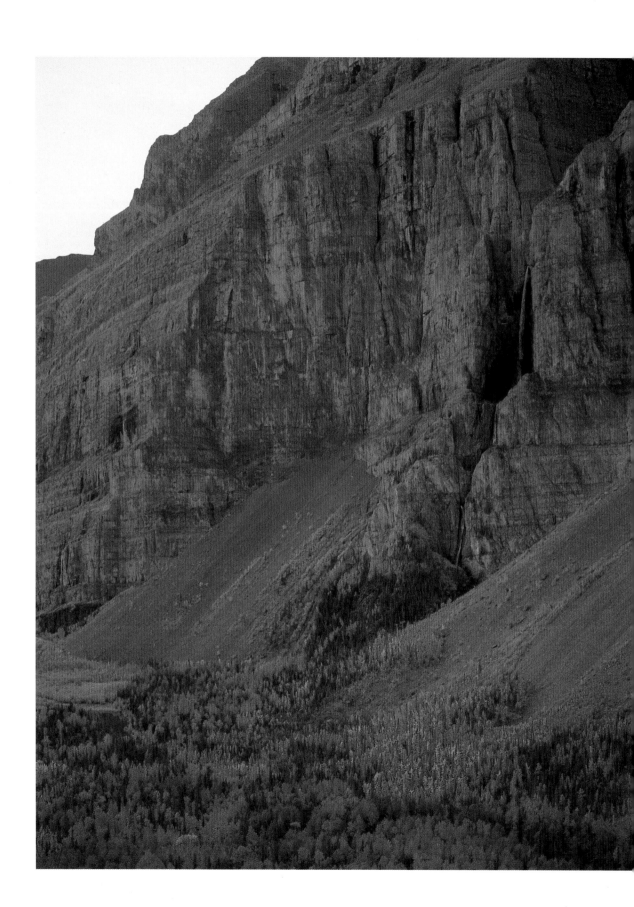

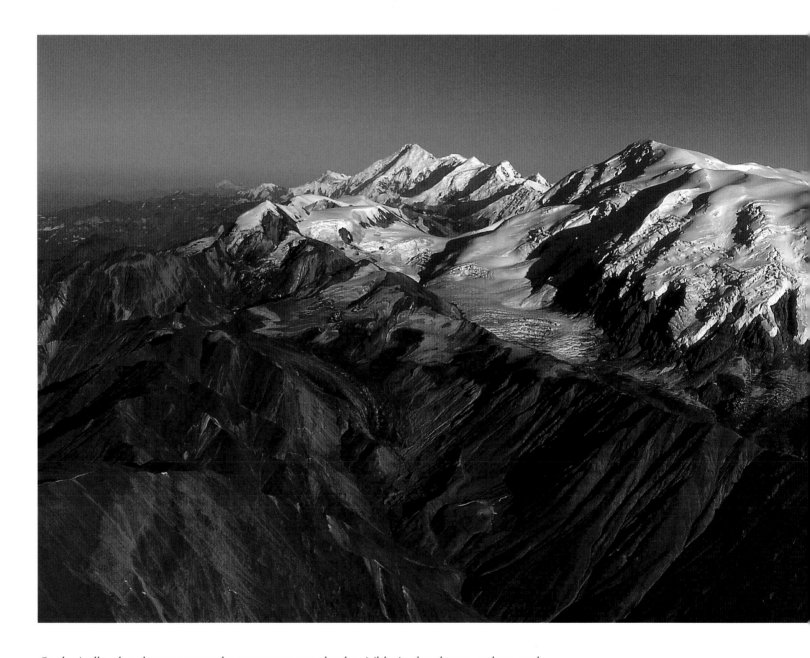

Geologically, the changes wrought over eons are clearly visible in the shapes, colors, and

textures of the landforms. The four great mountain ranges that command this region offer a

visually thrilling glimpse of exceptional scenic variety.

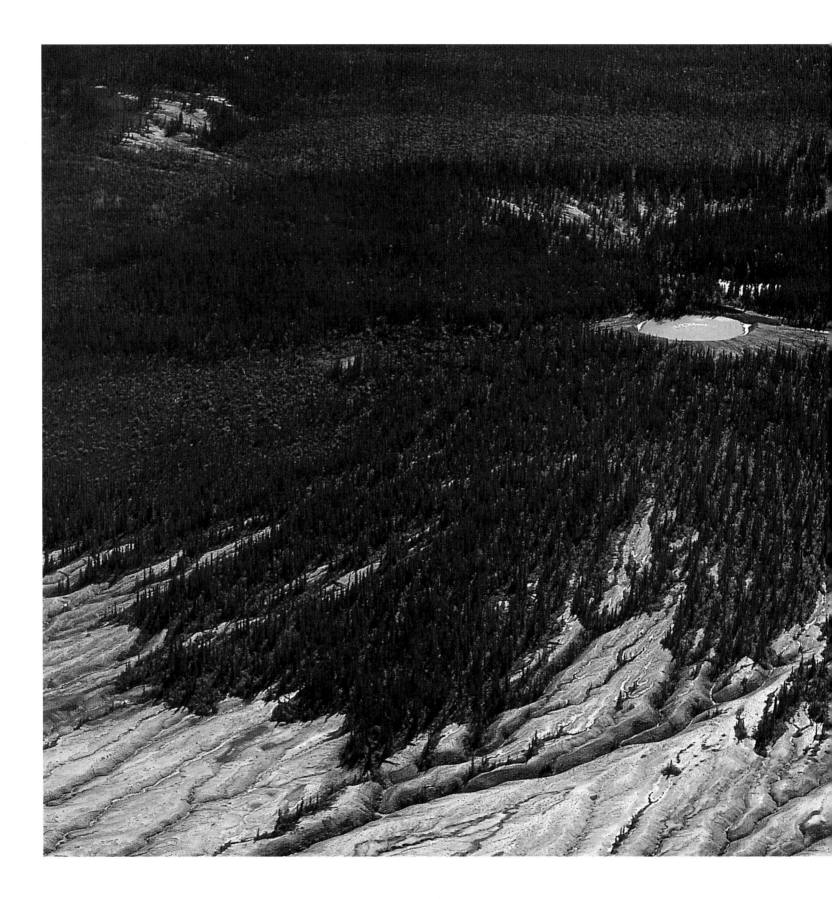

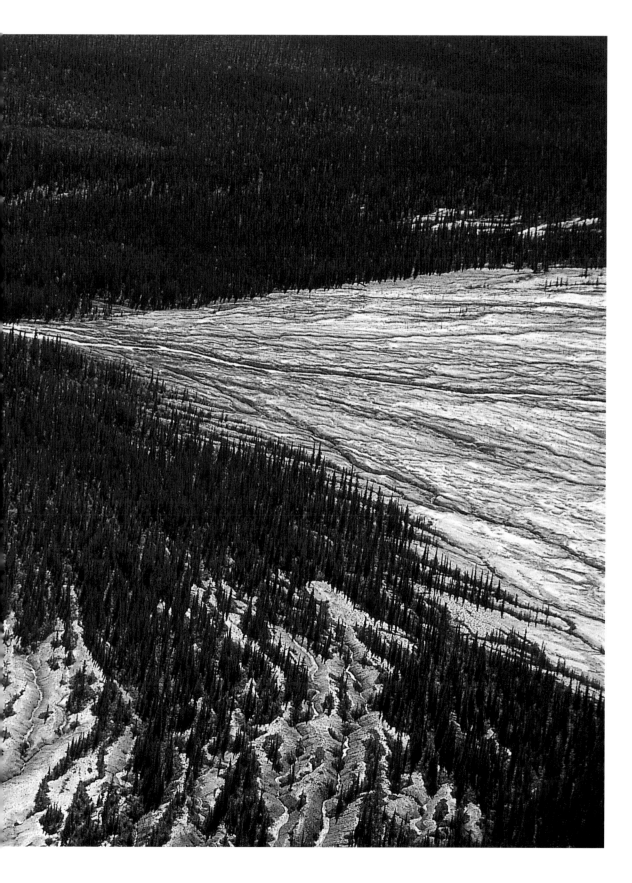

◄ Called mud volcanoes, these are not volcanoes in the usual sense, but mud-rich springs located west of Mount Drum near Glennallen and the Richardson Highway. The water discharged is thought by geologists to originate as a mixture of ancient seawater and water from cooling Mount Drum magma and limestones deeply buried in the Wrangellia terrain that are heated by enormous pressure and by nearby volcanic systems.

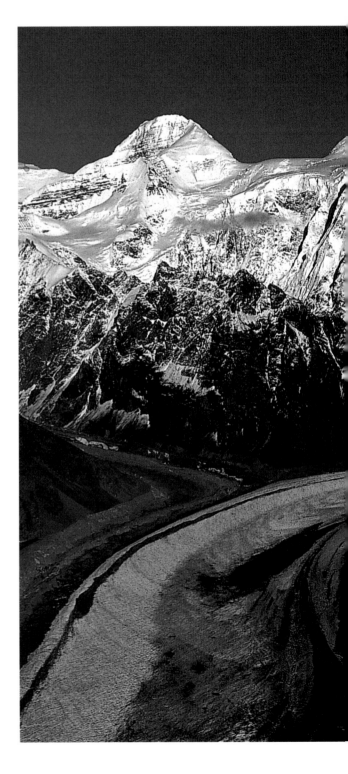

Here is an overwhelming place of mystery, beyond the safe boundaries of the

known. Ridges and minarets of rock and snow command the scene; fluted snow

and ice cover vertical surfaces.

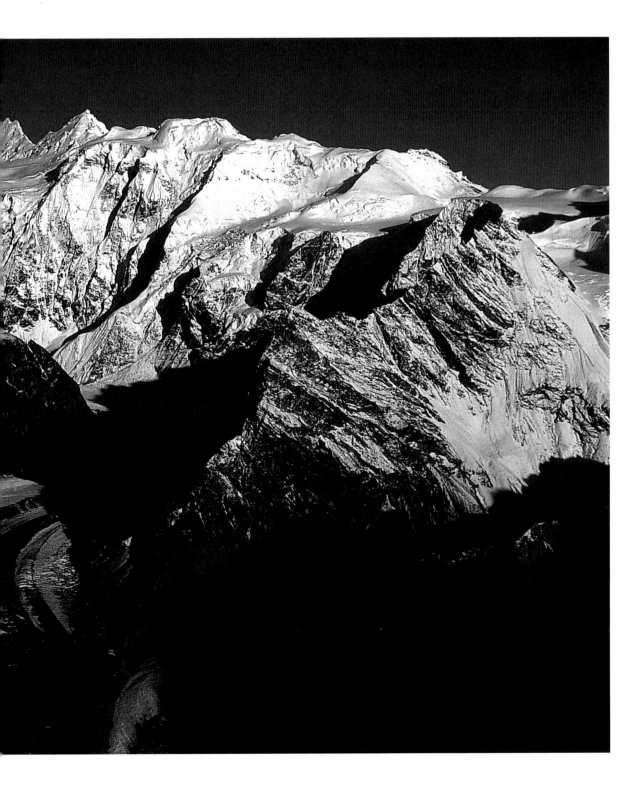

◄ Twaharpies and Twaharpies Glacier were named in 1967 by hydrologist and aerial photographer Austin Post, after the sirens of Greek mythology who lured sailors to their death.

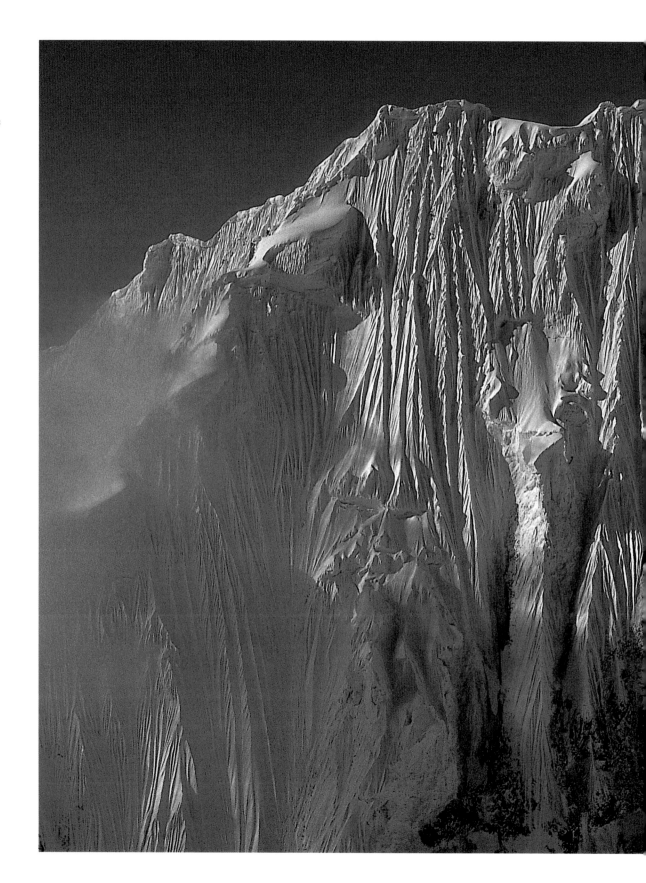

► Typical of scenery in the Hawkins Glacier cirque area is this unnamed ice-encrusted mountain.

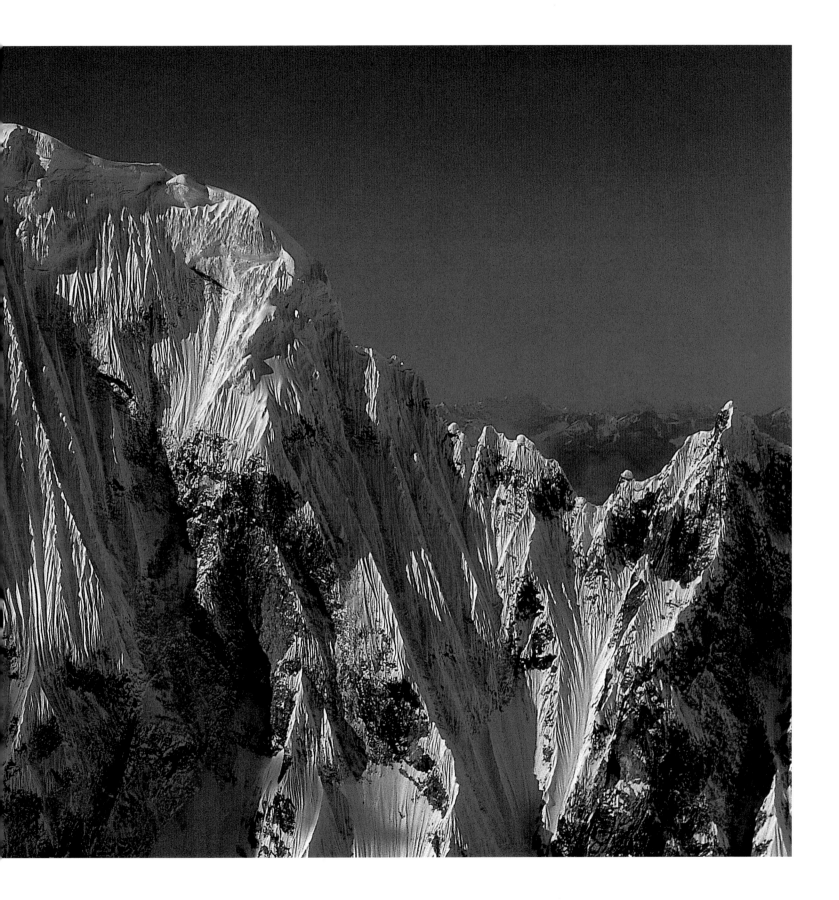

▲ Golden sunset light reflects from braided channels at the confluence of the Tonsina and Copper Rivers.

I see this park as a place set aside and protected from human depredation, where we can experience solitude and silence and beauty, where instead of our overwhelming nature, we can be overwhelmed.

A century and more from now, the park will still be here as a protected land. Such wild space will be needed even more desperately then than now, given the pace of man's assaults on nature. The creation of parks such as this one is a farsighted venture, an investment that can only become increasingly precious.

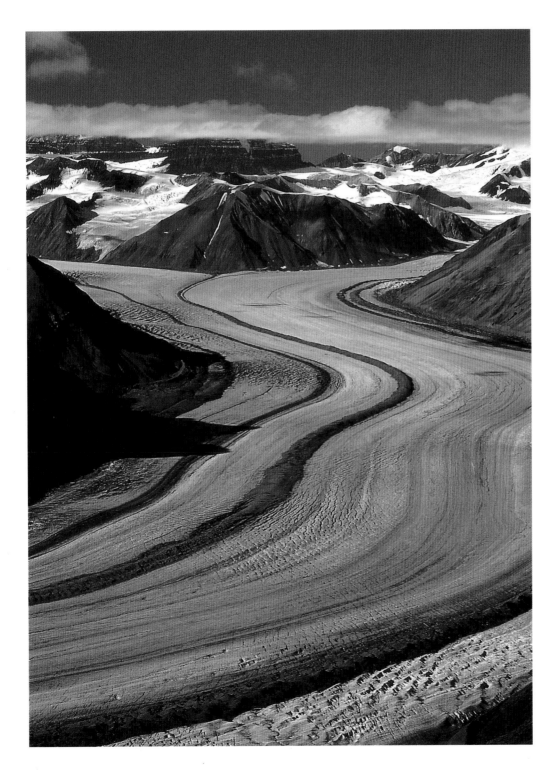

◀ Regal and Rohn Glaciers merge to form the Nizina Glacier east of McCarthy.

▶ **Gillam Falls near Tebay Lakes in the Chugach Range was named for "chill 'em, spill 'em, no kill 'em Gillam," as old-time bush pilot Harold Gillam was known. The waterfall creates a cloud of mist that coats nearby trees and bushes.**

▶ ▶ **A grasshopper on a balsam poplar leaf at our McCarthy cabin. A small creature such as this one is, to me, as important an inhabitant of these mountains as a moose or a sheep. Because they are so tiny, they're either not seen or ignored.**

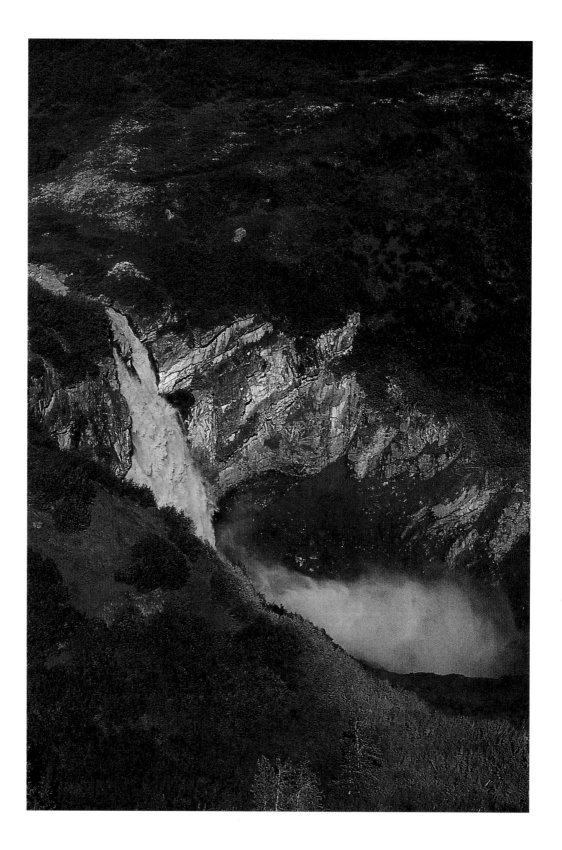

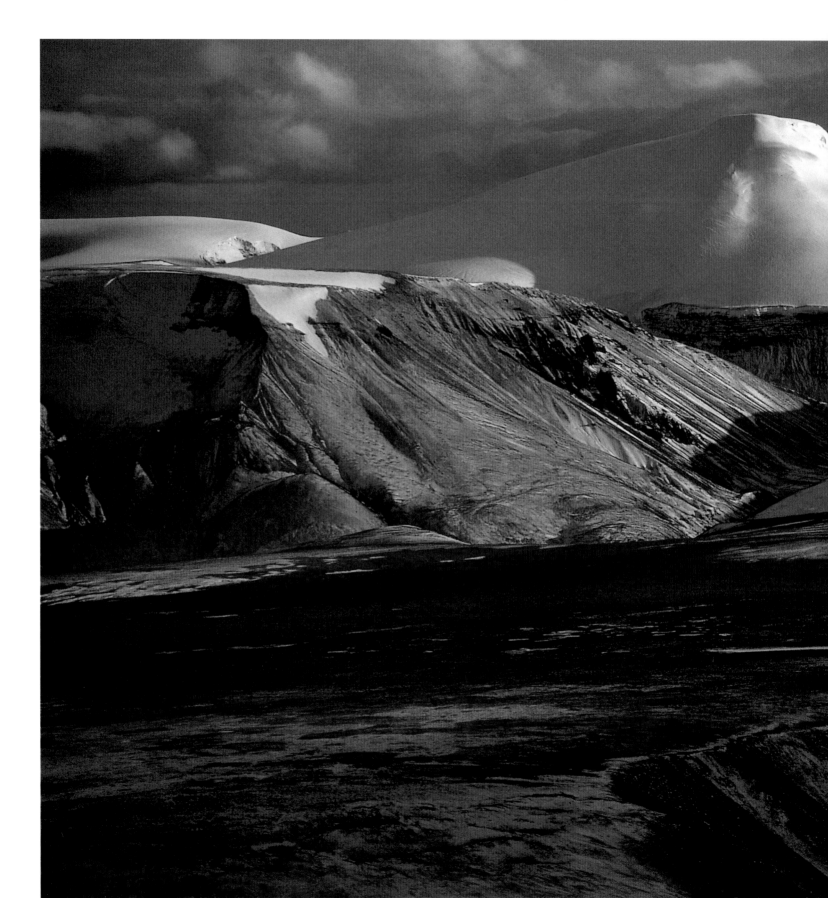

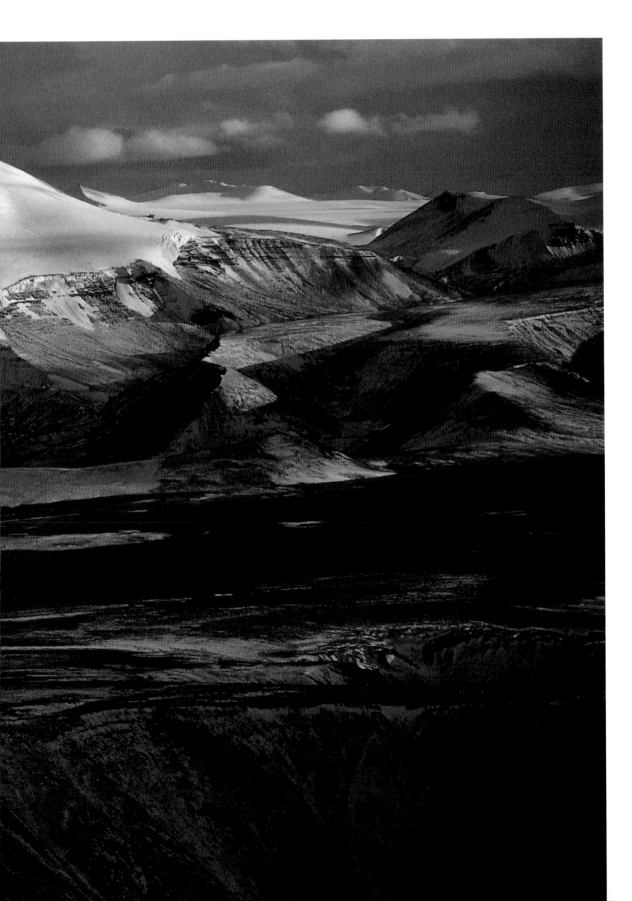

◄ Mount Gordon shows off winter's first snow. This old volcano cone perches in an area of large plateaus on the north side of the Wrangells.

Suggested Reading

Armstrong, Robert H. *Guide to the Birds of Alaska*. Seattle: Alaska Northwest Books, 1996.

Beston, Henry. *Outermost House*. New York: Rinehart, 1928.

Hunt, William R. *Mountain Wilderness*. Anchorage: Alaska Natural History Association, 1996.

Janson, Lone E. *The Copper Spike*. Anchorage: Alaska Northwest Publishing, 1975.

Kirchhoff, M. J. *Historic McCarthy*. Juneau: Alaska Cedar Press, 1993.

Leopold, Aldo. *Sand County Almanac*. New York: Oxford University Press, 1949.

Lopez, Barry. *Arctic Dreams*. New York: Charles Scribner's Sons, 1986.

Mull, Gill, and George Herben. *Wrangell–St. Elias—International Mountain Wilderness*. Anchorage: Alaska Geographic Society, 1981.

Olson, Sigurd F. *Reflections From the North Country*. New York: Alfred A. Knopf, 1977.

Richter, Donald H., Danny S. Rosencrans, and Margaret J. Steigerwald. *Guide to the Volcanoes of the Western Wrangell Mountains, Alaska* (U.S.G.S. Bulletin 2072). Denver: U.S. Geological Survey, 1995.

Rutstrum, Calvin. *Once Upon a Wilderness*. New York: Macmillan, 1973.

Smith, Dave (text), and Tom Walker (photos). *Alaska's Mammals*. Seattle: Alaska Northwest Books, 1995.

Tower, Elizabeth. *Ghosts of Kennecott*. Anchorage, 1990.

Williams, Howel, ed. *Landscapes of Alaska*. Berkeley: University of California Press, 1958.

Young, G. O. *Alaskan–Yukon Trophies Won and Lost*. Huntington, West Virginia: Standard Publications, 1947.

Index

Acknowledgments

Among the many people who have helped with this project, I am particularly grateful to Bud Seltenreich and George LaRose for several flights that resulted in some of the pictures herein, to Austin Post and Bob Jacobs for their explanations of place names, to former Wrangell–St. Elias Park Superintendents Dick Martin and Karen Wade, and to the present Superintendent Jon Jarvis and his staff, especially Margie Steigerwald and Danny Rosencrans, for their help and support. Also my thanks to Pat Hammond for her help long ago with research on material that evolved into the Kennecott chapter. I am indebted to the Alaska State Council on the Arts for a grant that helped defray flight cost and to Dan Dixon at the University of California Press for arranging permission to use the quote from T. K. Whipple. My thanks to George Mobley for his advice on picture selection, to Myron Wright for several photo flights in the park, and to Bill Hunt for help on early history of the region. A special thank you to Gary and Nancy Green of McCarthy Air. Without Gary's ability to read my mind and see pictures sometimes before I saw them myself, and the many hours of safe flying over a period of several years, the pictures wouldn't have happened. Nancy's cheerful support and encouragement together with occasional coffee and cookies smoothed many a bump out of the hours of aerial photography.

About the Author

George Herben first experienced the wild world at the age of three months from a packbasket in which he was carried to his family's home on a remote Adirondack lake in New York state. The many seasons he spent there as a young boy and later as an adult helped to form his sense of kinship with wilderness.

▲ Author George Herben on assignment following whales in Frederick Sound, Southeast Alaska. Photo by Marty Loken

Herben developed an interest in photography in the early 1950s while stationed with the U.S. Air Force in Alaska. Later, after working as a cyclotron technician and a field engineer, he became a photo instrumentation engineering technician. As project photographer, he flew as a civilian crew member on an Air Force ionospheric research aircraft, traveling to Europe, South and Central America, Antarctica, the North Pole, and remote corners of the Pacific.

For thirty years, Herben has done writing and photo assignments for organizations such as Chevron, the Brazilian Coffee Institute, and the trans–Alaska pipeline project. His stories and photographs have appeared in many major publications including *Audubon, Ranger Rick's Nature* magazine (one story received recognition from the Institute for Children's Literature), *ALASKA, Smithsonian, LIFE, National Wildlife, National Geographic, GEO,* and *Natural History.* In recent years, he has also done biomedical and mechanical engineering consulting. He and his wife live in Anchorage and McCarthy, Alaska.

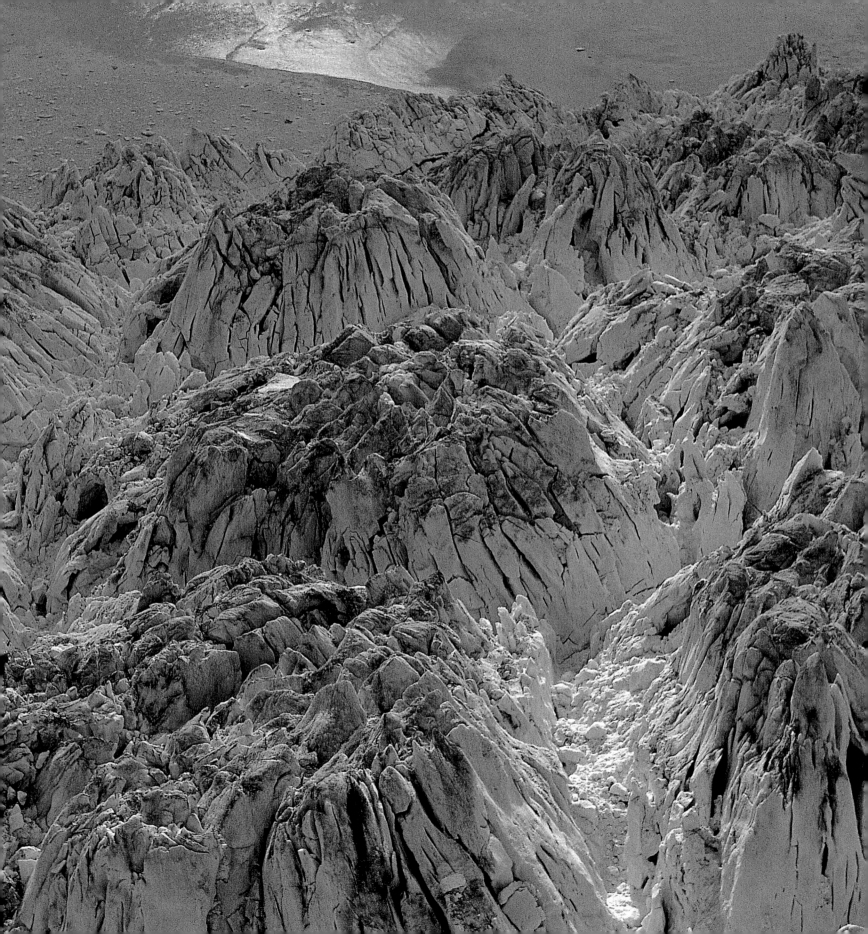

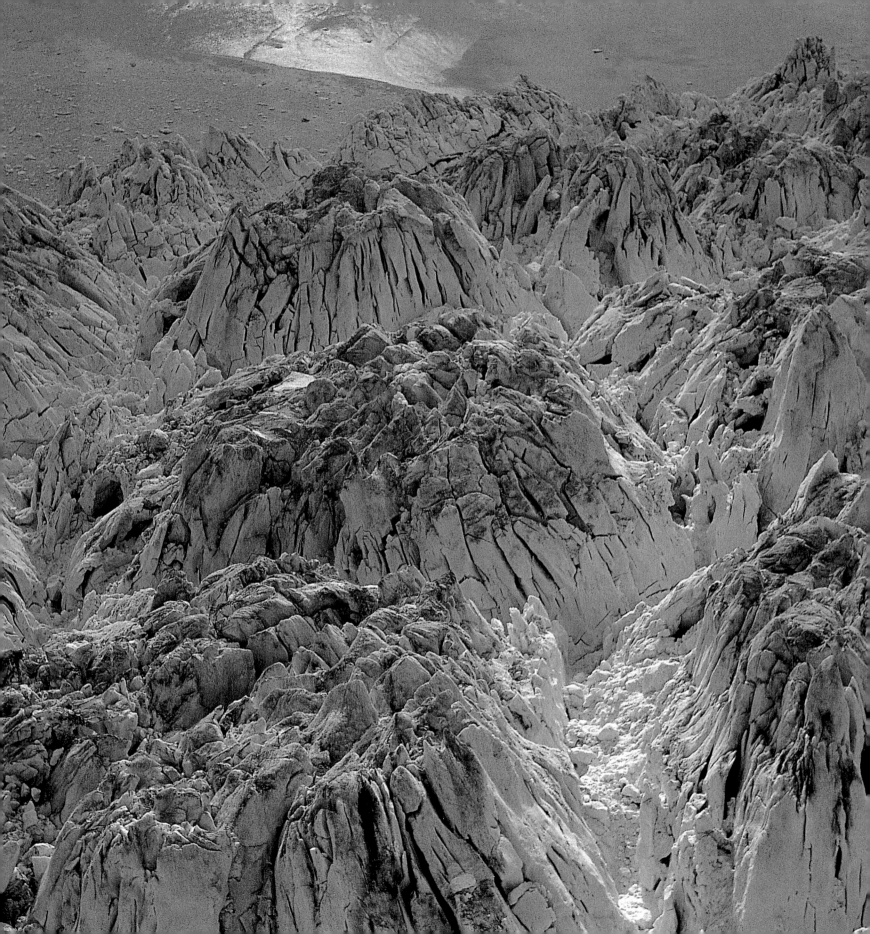